RICHARD DADD

Frontispiece

I *The Fairy Feller's Masterstroke* 1855-64, oil on canvas

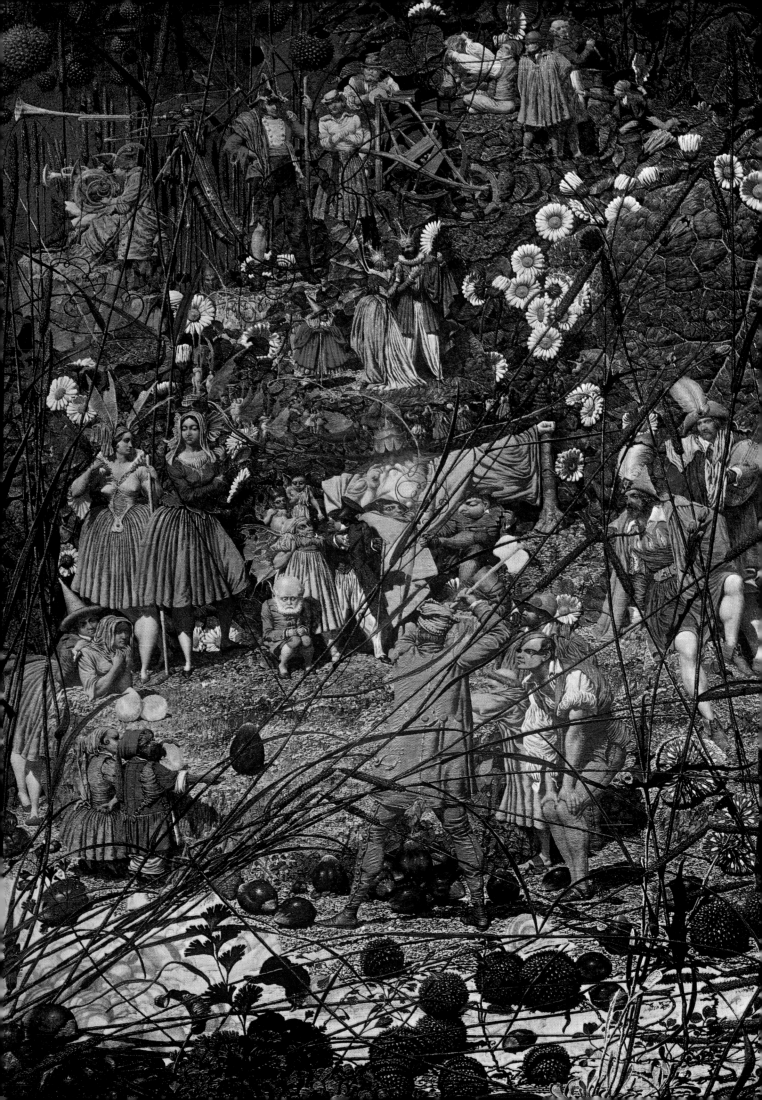

RICHARD DADD

by

PATRICIA ALLDERIDGE

ACADEMY EDITIONS · LONDON

ST. MARTIN'S PRESS · NEW YORK

To Ian and Jane Phillips

First published in Great Britain in 1974 by
Academy Editions 7 Holland Street London W8

First published in the U.S.A. in 1974 by
St. Martin's Press Inc. 175 Fifth Avenue New York N.Y. 10010

Library of Congress Catalog Card Number 74-78121

Printed and bound in Great Britain by
Burgess & Son (Abingdon) Ltd.

CONTENTS

ACKNOWLEDGEMENTS

For many years before I started my research on Richard Dadd, although I was not aware of this at the time, Mr. Ian Phillips had been engaged on the same work and but for the pressure of other activities would have completed it before ever I began. Nevertheless, he freely handed over the entire fruits of his research to be pooled with mine, giving up the long-cherished project of writing his own book and with unfailing generosity shared, helped and advised in the progress of my work. As well as expressing my thanks, I want to put it on record that in all but the final selection and writing, this book is truly a joint production.

Sadly I must also record my especial debt to the late John Rickett, whose pioneering article in *The Ivory Hammer*, 1964, 'Richard Dadd, Bethlem and Broadmoor', was the inspiration for my own interest in the subject, and whose unpublished material was put at my disposal after his death. To Mrs. Alys Ricketts, who so generously allowed me to use her late husband's work as well as giving unlimited access to his collection of pictures, I offer my most sincere thanks.

All the museums and galleries whose names are individually listed in the captions have kindly given permission for their pictures to be reproduced and in many cases have also supplied photographs. I am very grateful for their co-operation and help. I am especially grateful to the private owners, including those who by their own wish remain anonymous, who have similarly given permission, and to all those who have shown their pictures to me over the years. It is a real pleasure at last to be able to acknowledge publicly, all the help, encouragement, hospitality and lasting friendship which I have received from many people to whom my only introduction was an interest in the work of Dadd. In making this collective acknowledgement, I hope that each will read into it my separate and appropriate thanks for countless kindnesses.

Many private individuals and the staff of galleries, libraries, record offices, sale rooms and other institutions have contributed to this work by locating pictures and manuscripts, supplying information and opinions, and in numerous other ways. In particular I thank Mrs. Patricia Barnden of the Paul Mellon Centre, London (whose invaluable help with the photography would have placed her first even in a non-alphabetical list); Mr. David Carritt; Miss Beverly Carter, Secretary to the Paul Mellon Collection in Washington; Mr. Julian Doyle; Mr. Edward English of Broadmoor Hospital; Miss Naomi Evetts of the Liverpool Record Office; Mrs. Robert Frank; Miss Helen Guiterman; Mr. E. Holland-Martin; Mr. John F. Hudson of Christie's (who constantly produced previously unknown pictures for me, like rabbits out of a hat); Mr. Lincoln Kirstein; Mr. Jeremy Maas; Mr. H. L. Mallalieu of Christie's; Mr. Alister Mathews; Mr. Edward Morris of the Walker Art Gallery, Liverpool; Miss Gabriel Naughton and other members of the staff of Thomas Agnew & Sons; Mr. John Page-Phillips; Mr. Leslie Parris of the Tate Gallery; Mr. Andrew Patrick of the Fine Art Society; Mr. Alan Pearsall, Custodian of Manuscripts of the National Maritime Museum; Mr. R. J. Raymont, formerly of Broadmoor Hospital; Miss B. R. M. Riddell of Chatham Public Libraries; Mr. Leslie Shepard; Sir Sacheverall Sitwell Bt.; Mr. Dudley Snelgrove; Mr. Stephen Somerville of Colnaghi's; Mr. Allen Staley; Mr. Paul Thomson and other members of the staff of Sotheby's.

In 1971, I received a grant towards the cost of research from the Paul Mellon Centre for Studies in British Art, which since that date has also undertaken a great deal of the photography: I am very grateful to the Centre and to its director of studies Professor Ellis Waterhouse for this assistance.

RICHARD DADD

Richard Dadd began his working life the year in which Queen Victoria came to the throne and Constable died; by the time of his own death the Pre-Raphaelites had come and gone, the first French Impressionist exhibition had taken place, Sickert had just started his career, while Landseer and Palmer had finished theirs. The intervening five decades had seen the English picture-viewing public outraged by *Christ in the House of His Parents,* stirred by *The Monarch of the Glen,* edified by *Past and Present,* overwhelmed by Rossetti, reassured by Frith, blandished by dogs and children, and charmed by bandbox beauties. In chronological terms he is thus the complete Victorian, his forty-nine active years spanning the development of all those trends in English mainstream painting which, justly or unjustly, are associated with the word Victorian.

If his work shows little of this background, it might be argued that all the major painters of the period lived through it and retained their individuality, while others produced honourable results well within the increasingly prosaic traditions. But Dadd did not live through it, and on examination it will be seen that his life scarcely impinges at all on the epoch to which, ostensibly, he belongs. For he was cut off at the age of twenty seven from all the currents and eddies of fashion, the changing attitudes of society and even the influence of friends and colleagues, by the most effective barrier this side of the grave, the walls of a criminal lunatic asylum. Without needing to regard even the exigencies of economic survival and without access to the stimulus of outside criticism he was in the rare position of spending the major part of his productive life subjected to no established values and measured against no judgement but his own, painting to please no one but himself, with the knowledge that his work could never in his lifetime alter his personal status by a hair's-breadth. Thus more than any other painter he stands alone as an isolated phenomenon, working almost outside time itself and belonging, if he belongs to any period at all, to the few short years of professional experience which led up to his incarceration in 1844.

A painter with less powerful motivation and less secure perception might not have been able to withstand such isolated independence and one who worked in a naturalistic tradition would have been crippled by it; but for Dadd, who was already deliberately rejecting this line to pursue his own intensely personal exploration of the world of fantasy, it meant in the long run a form of escape, a freedom to push his exploration even further along paths which could only be trodden alone. This factor more than anything else singles out his work from that of his contemporaries and emphasises the extraordinary purity which is its chief characteristic. His *oeuvre* is, more literally than any other, the product of a single version subject only to the limits of its own capacity.

The training, influences and experience which Dadd took into the asylum with him formed the basis for the rest of his life's work — and up to that time, they had been ordinary enough.

He was born on 1 August 1817 at Chatham in Kent, the third son and fourth child of a successful chemist. Robert Dadd was a man of intelligence and energy who played a leading role in the town's cultural life, helping to found several educational institutions and schools. He was the first curator of its museum, a good lecturer on geology as well as chemistry, a kindly and sensible man who was popular among his fellow townsmen and,

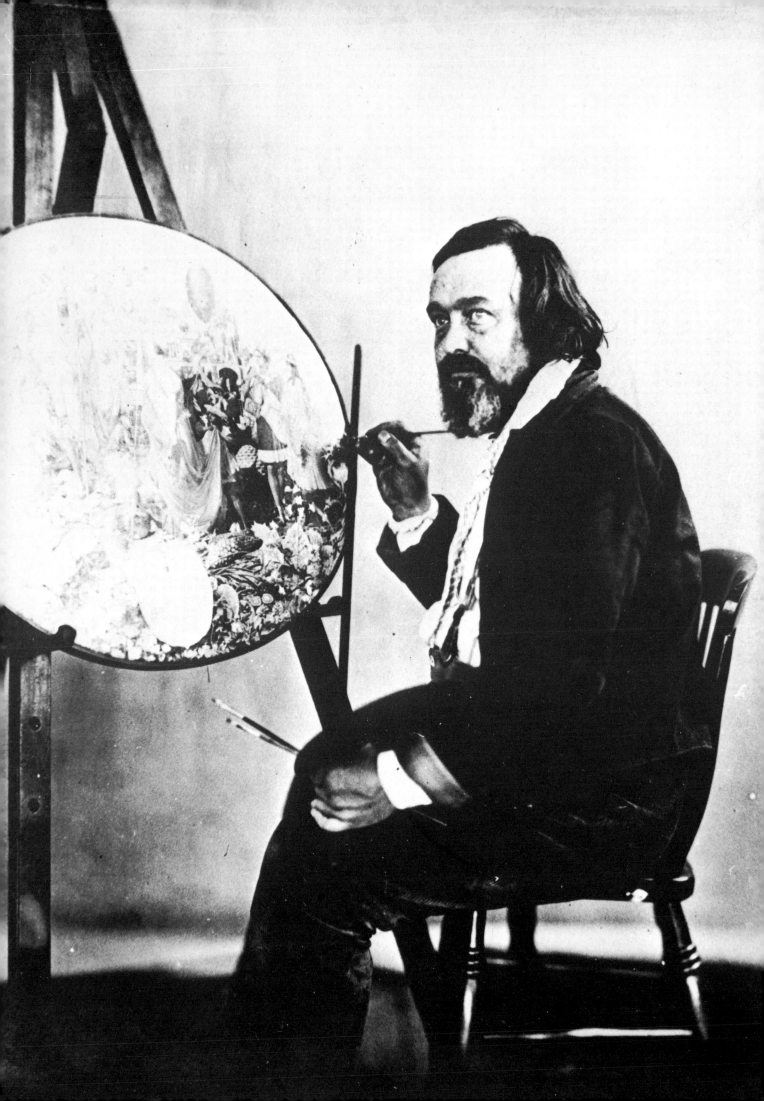

almost certainly, among his large and equally intelligent family.

Dadd was one of seven children by his father's first marriage, but his mother died when he was just short of seven years old in 1824. Little is known about Mary Ann Dadd except that she came from the Martin family of Gillingham, who were as well established in the area as the Dadds and came from much the same social stratum. His father married again, though it has not been possible to trace the origins of his second wife, Sóphia Oakes. She bore him two more sons and also died young, leaving the family motherless in 1830 for the second time.

Robert Dadd must therefore have been a dominating influence in his children's lives, and they probably owed to him their love of literature and the liberal outlook which can be seen in their later letters. In all likelihood, Richard inherited his artistic talent from him as well, and certainly received every encouragement to develop it. He attended the grammar school at Rochester until he was thirteen, but the scholarship of his later years is evidence that his education did not stop at this point. It was about the time when he left school that he began drawing seriously, and the next few years were spent sketching in the countryside around his home. He must have been taught by someone during this period, and the most likely person was the proprietor of the local drawing school and a colleague of his father in educational undertakings, William Dadson.

Someone who knew Dadd well later recalled that 'his drawings were much admired before he attempted to paint in oils', and that his first painting was of 'shipping', but there is no record of when that attempt was made. Judging from his lifelong enchantment with boats a good deal of time must have been spent making studies around the Medway and on the coast, but the only surviving works from this period are some small landscape sketches and a portrait of a girl dated 1832. The landscapes are conventional and pleasant in the tradition of the early part of the century. Undated, they tell little of his early progress. The portrait however is a highly competent work for a fifteen year old, and the treatment of the face in particular seems to show an acquaintance with the technique of miniature painting. Dadd's preference was always for small-scale work, and as many of his pictures can be classed as miniatures on stylistic grounds as well as by measurement, it would be interesting to know whether his earliest training was in this field.

In 1834 Robert Dadd gave up his chemist's shop and moved with his family to London, taking up the business of a bronzist and watergilder. This occupation was already practised by one member of the family in Chatham, and his second son Stephen also followed in the same business. It is not known why he moved, nor what associations he may already have had with the London art world, but, within a year or two, he had become a close friend of David Roberts R.A., and moved in a circle which included the printseller and art journalist William Clements, Henry Josi, Keeper of Prints and Drawings at the British Museum, and the Liverpool miniaturist John Turmeau.

All these people showed an interest in his son's career, particularly David Roberts and his friend Clarkson Stanfield, and no doubt they advised on his future prospects. Dadd began by studying at the British Museum, where drawing from casts was a probationary training for the Royal Academy Schools, and he was admitted to the Schools in 1837. He was then living with his family at No.15 Suffolk Street, Pall Mall East, which was also his father's business premises. The household was run by the eldest daughter Mary Ann. His first

Richard Dadd at work on *Oberon and Titania* c.1856

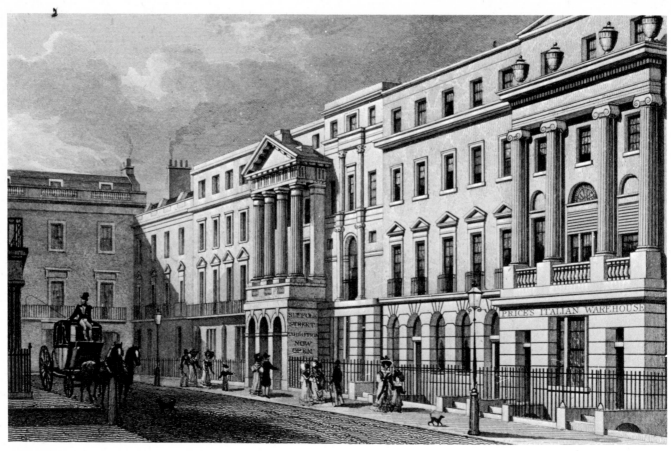

1. Suffolk Street, Pall Mall East, London, contemporary engraving

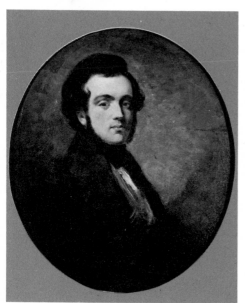

2. *Portrait of Robert Dadd jun.* c. 1840, oil on board

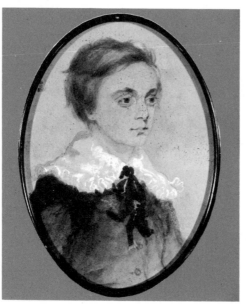

3. *Portrait of John Alfred Dadd* c. 1839, watercolour

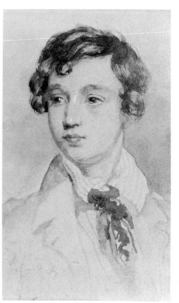

4. *Portrait of George William Dadd* c. 1840, watercolour

brother Robert, a chemist like his father, was probably independent by now; Stephen, the second, later managed the Suffolk Street business. The youngest full brother, George William, who was also to be confined in Bethlem Hospital incurably insane, became a carpenter at Chatham dockyard, a trade which had occupied members of the family in previous generations. The other girls were Sarah Rebecca and Maria Elizabeth, then aged eighteen and sixteen respectively, while the two half brothers by Robert Dadd's second marriage, Arthur John and John Alfred, were ten and nine.

In 1837, when the Royal Academy was moving to its new accommodation in the National Gallery building in Trafalgar Square, only a minute's walk from Suffolk Street, Dadd's fellow students became known to the family. His closest friend, William Powell Frith, entered the Schools in the same term, as did John Phillip, who later married Maria Elizabeth Dadd. Other intimates were Augustus Egg, Henry O'Neil, Thomas Joy, E.M. Ward, and 'our sublimated friend Gibson', while several others such as William Bell Scott were loosely associated with them. These young men formed a sketching club known as The Clique, which met weekly in Dadd's rooms after he had left home to live in Great Queen Street. Outsiders would be invited and were often called on to judge the week's best illustration of a chosen subject, which was frequently Dadd's. Byron and Shakespeare provided the most popular themes. Dadd also painted portraits of the group and their friends in appropriate character roles, of which the portrait of Augustus Egg is an example.

Dadd was generally held to be the leading talent within his circle, by teachers as well as friends. In 1839 he won the painting school's second silver medal for copying, the third for drawing from life and in 1840, the silver medal for the best life drawing. He was recollected by Frith in his *Autobiography* as 'a man of genius that would assuredly have placed him high in the first rank of painters . . .', and at rather closer hand he was described by a distinguished Academician as 'foremost among the rising young men of the age' and one of the most regular and attentive students the Academy Schools had ever known.

This diligence was to stand him in good stead, for the thoroughness and discipline of his early training were among the factors which enabled him to recommence and continue painting at a time when his own mental turmoil was matched by the chaos of his surroundings. In spite of its great inventiveness, Dadd's work was always based very firmly on academic principles; and he often used ideas, adapted in a highly personal way, which he had borrowed from the wide range of his art history studies. He had thus more to fall back on than many of his contemporaries and his extremely disciplined manner of work found him at the crisis with a technical mastery so deeply ingrained as to be practically second nature — one which could carry him almost mechanically through his worst period when everything else that was familiar had disintegrated around him.

He began to exhibit in his first student year with a *Head of a Man* at the Suffolk Street Galleries, followed, in 1838, with three landscapes. These have not been traced, but several small landscapes from the previous year, *The Bridge* and *Landscape,* show him versatile but still unformed, painting with a looseness of texture wholly at variance with his later work but with the competence which he always brought to everything he attempted. There is no doubt that one of his first interests was landscape, though this branch of painting was just beginning to decline from its eminence and the Academy soon turned his attention elsewhere. He was to recapture this early love many years later in circumstances which would seem wholly unfavourable, and the cool incisive landscape backgrounds of some of his Bethlem watercolours are amongst their greatest joys. Later still his inspiration led him back to pure landscape and seascape, at a time when his sight of the outdoor world had been restricted for nearly twenty years by the high brick wall of a grass-and-gravel exercise

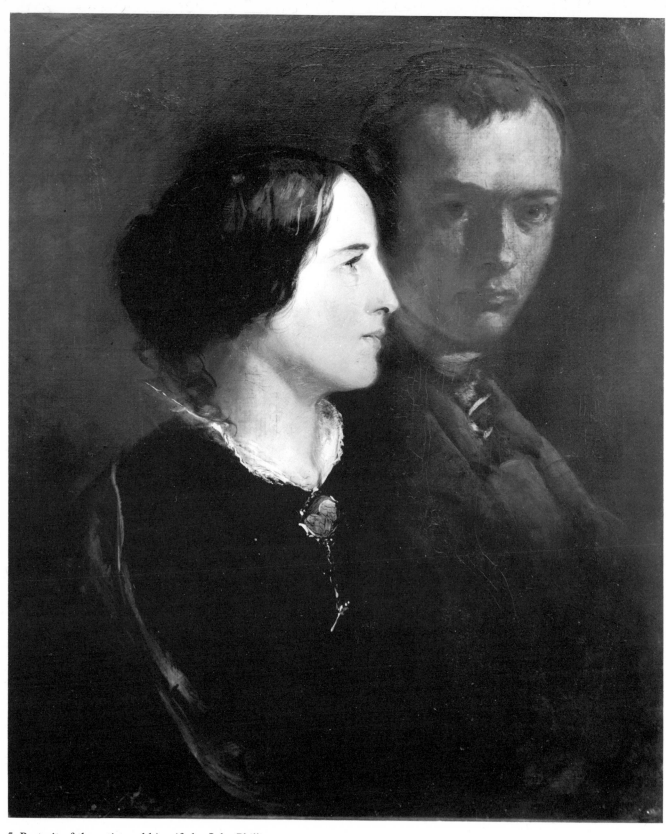

5. Portrait of the artist and his wife by John Phillip

yard. The visionary intensity of such works as *A Dream of Fancy* and *Port Stragglin* are testimony to the deep commitment made during his formative years.

He also, around 1838 and 1839, painted lively little watercolour portraits of family and friends of which *Family Portraits* and *Portrait of John Alfred Dadd* are good examples. These are small enough to be classed as miniatures, but use flat washes rather than the elaborate stippling and hatching used in the early portrait of his sister and for many later subjects to achieve fine detail. Among his more casual work in oil from this period are more small portraits, and two still life paintings one of which, incorporating a prophetically wicked looking knife, measures only 3″ x 4″.

At this time the pre-eminence of history painting, taking this to include illustrations from literature as well as ancient and classical history and the Bible, could not be ignored by a young painter hoping to make his mark. In 1839, Dadd accordingly moved into the field with a *Don Quixote* at the Suffolk Street Galleries. He made his first sale with the same picture, and exhibited a *Study of a Head* at the Academy and *Toby Fillpot* at the British Institution. The following year consolidated the advance into history, with *Alfred the Great in Disguise of a Peasant Reflecting on the Misfortunes of his country, Elgiva the Queen of Edwy in Banishment,* and scenes from *Hamlet* and *As You Like It,* along with an indeterminate *Venetian Minstrel* shown at the British Institution.

Of these only *Hamlet* has been traced. It is quite large by Dadd's standards, about 4′ x 3′ in its present slightly cut-down state, and is notable chiefly because he chose to depict his two protagonists, Hamlet and Gertrude, in a state of extreme terror at the supernatural visitation of the ghost. This might be unremarkable in anyone else, but in view of Dadd's own demonic persecutions three years later his choice of this scene might indicate an incipient interest in the subject of haunting. It is not fair, however, to judge the rest of his output from this one picture, nor safe to assume, from the titles alone, that his work was in the rather unexciting style of his contemporaries who were painting similar subjects. Indeed from what we know of his work of the following year, it is reasonable to suppose that some of these early exhibited pictures contained at least sparks of the brilliance which was so shortly to appear.

Because so little else has survived, the fairy paintings of 1841 and 1842 come as something of a shock, but at least their quality was no surprise to his contemporaries, who were always aware of his outstanding ability as a draughtsman. Whether the rich vein of fantasy had been heralded in other works is not known, nor whether his admirers appreciated the extreme restraint with which he handled the impulses of an extraordinarily vivid imagination; but they certainly appreciated that imagination itself, the fertility of his invention, the intelligence and originality of his ideas and his sheer technical bravura.

The three major works of 1841 were *Titania Sleeping,* exhibited at the Academy, *Puck,* at the Suffolk Street Galleries and *Fairies Assembling at Sunset to Hold Their Revels,* (now lost) shown at Manchester. In 1842 he showed *Come unto These Yellow Sands* at the Academy. Also dating from around this time are a small study of a single figure, untitled, but known as *Evening* and containing many characteristics of the more elaborate works and a watercolour sketch for a missing painting, *The Fairys' Rendezvous.* The *Art Union*'s reviewer was emphatic that Dadd was the 'poet among painters', and there is indeed something about these works which is very difficult to describe in any other terms. The small self-contained world which he creates has all the formal elegance of a sonnet, its beauty expressed through internal harmonies and rhythms, refined and purified by the restrictions within which it is deliberately confined.

In structure the fairy paintings owe a great deal to the example and teaching of Daniel Maclise, who was admired to the point of adulation by all of Dadd's circle. The emphasis on surface pattern, seen here at its most distinctive in the arabesques and ellipses of *Come unto These Yellow Sands,* the use of foliage to form a flat decorative border in *Puck* or the still more inventive proscenium arch of *Titania Sleeping,* the idea of setting part of the scene in a deep recess within the picture, used for the main group in *Titania,* and the creation of tension by dramatic lighting are all formal devices highly characteristic of Maclise. Equally characteristic are the meticulous draughtsmanship, love of fine detail and fertile imagination, none of which, however, could have been acquired by mere emulation had they not already been innate.

For all their derivativeness there is no element of slavish copying in these pictures, and already Dadd shows a fluency and control in handling highly artificial designs which goes far beyond Maclise and is entirely his own; he especially never allows himself to be encumbered by Maclise's craving for symmetry. Dadd uses intricate detail as an essential part of his total vision rather than mere decoration, a virtuoso embellishment which tends to dazzle and confuse when applied to the surface of large and crowded compositions. By working on a small scale he was able to keep a sense of proportion in a very literal sense, and his exploration of the highlights in a dewdrop or the texture of a flower petal was an important part of his way of looking at the minutely ordered universe which he created.

The most striking feature of these pictures, and one which distinguishes them from other nineteenth-century fairy paintings, is the order and completeness with which he creates an environment in which the elements have materialised — for they could never have come by natural means. There is a total unity of landscape and figures in which neither could exist independently of the other, it is their only possible habitation, they its only possible inhabitants. We are not looking at a small corner of the familiar world populated by tiny people, but at an enchanted place existing in its own right and on its own terms. To understand this it is only necessary to try to imagine Dadd's fairies in the hearth or sitting down to nursery tea around a toadstool, or to introduce into one of his settings that popular denizen of the fairy world, a giant mouse.

The totality of these pictures removes them from any context outside their own self-enclosing frames, and significantly two are contained within inner-painted frames and the third has an arched top which produces the same stage-like setting. The effect is partly achieved by the brilliant use of highly dramatic lighting, setting up tensions which hold the figures in the centre of their luminous world with the power of centrifugal force. The same light also defines the precise area in which they are permitted to move, the area in which they are trapped by the intensity of their own self absorbtion; they are trapped also by the intensity of Dadd's observation, like the creatures in a drop of water seen under high magnification.

For Dadd, fairy painting was a serious business, an act of the most intensely personal creation. It had nothing to do with the whimsy — despite his ability to charm and please by purely fanciful and playful touches — the voyeurism, sometimes the sadism with which his contemporaries often achieved popularity in this field. For fairy painting was also a way of exploring nature, as his landscape painting later became in Bethlem; but a way of exploring by putting it under a microscope, discovering a world in a grain of sand.

In spite of this preoccupation with the world of fantasy in his art Dadd was described as 'a man of strong common sense, the reverse of flighty or excitable' in his daily life, and he was one of the most popular in his set because of his cheerful and intelligent conversation

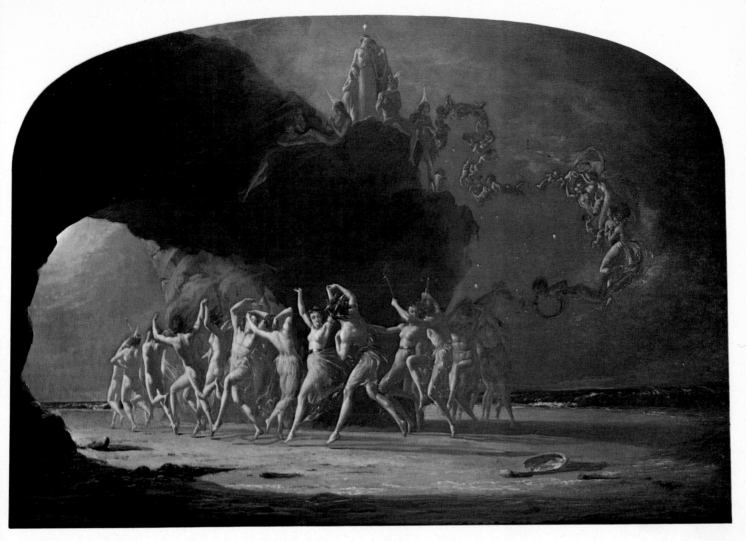

II *Come unto these Yellow Sands* 1842, oil on canvas

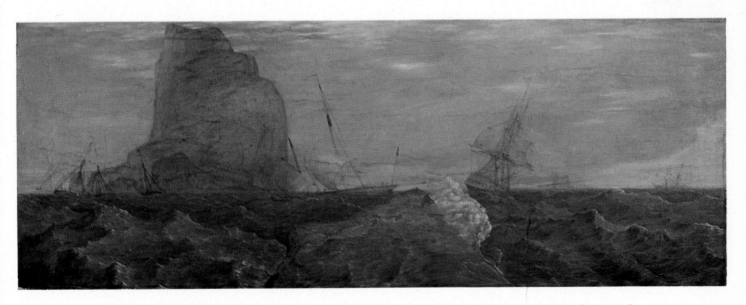

III *The Diadonus Advancing Backwards and Giving a Heavy Lurch to Windward* 1861, oil on panel

Overleaf
IV *Caravan Halted by the Seashore* 1843, oil on canvas

V *The Flight out of Egypt* 1849-50, oil on canvas

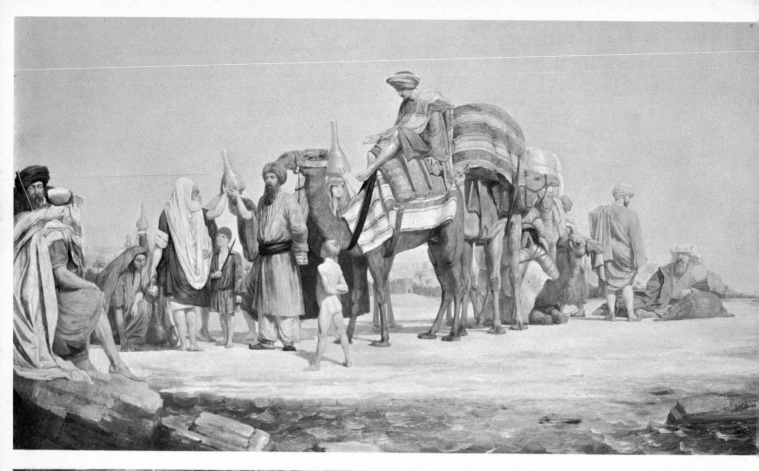

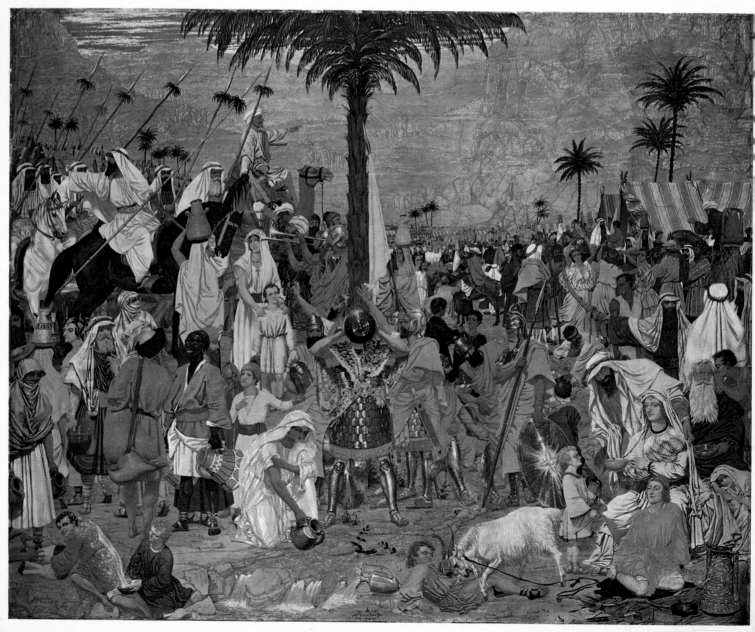

and generous nature. Eager to earn his living, he was a leading member of a group, consisting basically of members of The Clique, which met to discuss new ways to provide exhibition facilities for those who felt themselves kept back by monopolising Academicians. It came to nothing; but in any case Dadd had now found in his fairy world an outlet for his genius which also seemed to assure him of future success. It is always open to question whether, had he been able to carry on in the same vein, he might have been in danger of slipping into a facile formula calculated to please the public. But as events turned out, there was never time for this to happen.

Around 1841, he received an important commission from Lord Foley to provide the decorations for a newly acquired house in Grosvenor Square, and although none of these can be traced they were described by contemporaries as his most outstanding work. They consisted of a large number of panels, about one hundred by some accounts, of illustrations to Byron's *Manfred* and Tasso's *Jerusalem Delivered*, the choice of subject being apparently his own. It is a particularly significant choice in the case of *Manfred*, which Byron himself described: 'Almost all the *dram. pers.* are Spirits, ghosts, or magicians . . . so you may suppose that a Bedlam tragedy it must be . . .' Later he was involved in a commission to design wood engravings for one of the entries in the ubiquitous S.C. Hall's *Book of British Ballads*, illustrating the 'Ballad of Robin Goodfellow', again full of haunting sprites. Dadd was attracted to the medium and would probably have gone on to more work of this kind if time had allowed. He had also taken up etching, of which a few rare examples have survived and was a founder member of the Painters' Etching Society early in 1842.

In 1842, therefore, he stood on the threshold of a most promising career; but in this year came the event which marked, if it did not actually cause, the sudden and total disintegration of all his prospects and, for a time, of his whole life. The year began, however, in an atmosphere of the greatest confidence and hope.

In July he left England to accompany Sir Thomas Phillips, a former mayor of Newport, on a ten-month journey through Europe and the Middle East to make sketches of the places visited. The commission, obtained through his father's friend and his own patron David Roberts, from whom Phillips had asked advice in the choice of a travelling companion, offered unrivalled opportunities to widen his experience in all directions, to study paintings in Europe, and to gather material in the Middle East which could be used for future work.

The area through which they were to travel was at this time proving to be an increasingly potent lure to artists, and Robert's own recent tour had both primed and proved the market for Middle Eastern subjects. Wilkie had died a year earlier on his way home from the Holy Land, Muller would be in Asia Minor the following year, G.F. Lewis was already in Cairo laying the foundations for his work of ten years hence and Lear, Holman Hunt, and Thomas Seddon were all to make the journey in the early 1850s. For a young painter at Dadd's point in his career, such an opportunity could literally be the chance of a lifetime; and, in a quite unlooked-for way, it did in fact furnish a great motivating theme for the rest of his life. For these ten months were Dadd's last experience of the rational world, an experience which so powerfully stamped itself on his mind as well as his sketchbook that it was still providing inspiration and imagery for his work thirty-five years later.

In 1842 Dadd was twenty five, and Phillips fourty one, the latter a little pompous perhaps, but a dedicated tourist filled with a desire to see everything of artistic and historical worth from Ostend to Thebes. There was nothing to suggest that in the ordinary course of things,

the companionship of the two men would not have flowed smoothly during the trip. As it was, there was no hint of trouble in all the nineteen monster step-by-step travelogues which Sir Thomas sent back to his brother's family in Wimpole Street as the tour progressed; but it is known from other sources that by the last part of the journey Dadd was already showing signs of insanity, and had become fixed in the delusion that Sir Thomas was an object for detestation as an emissary of the Devil.

The first phase of travelling, down the Rhine, through the Swiss Alps, across northern Italy to Venice and down the east coast to Ancona, is not recorded in Dadd's surviving sketchbook, which is now in the Victoria and Albert Museum. Although no direct pictorial record has yet been found, some of the later watercolours from Bethlem and Broadmoor may have been inspired, in their precipitous rock faces and pinnacled castles, by memories of the scenery or by drawings in the other sketchbook which he had with him in the hospital. But anyway, the days of climbing in the Alps were so strenuous that there could not have been much time for sketching, and the Italian section was chiefly devoted to pictures and architecture. Dadd wrote of Venice to David Roberts that 'The pictures of Paul Veronese and Tintoretto are the most marvellous things imaginable in respect of execution and colour', and he praised Titian, Bellini and Bonifazio. He found Tintoretto's *Miracle of St Mark* 'one of the most fascinating works I ever beheld', and at Bologna he thought Guido to 'far exceed his masters the Caracci'. Not surprisingly, what he admired most in Veronese was 'the pure daylight . . . and surpassing brilliancy of colour', showing that 'lightness of effect depends on the artist and not the material'.

The surviving sketchbook begins after they had crossed to Greece and from this point on the pages are filled with lively sharp vignettes of landscapes, townscapes, architectural details, and above all of people and boats. From Greece to Smyrna, Smyrna to Constantinople, through southern Turkey, Lebanon, Syria and finally Egypt, Dadd crammed into this small book, sometimes fifteen or twenty to a page, buildings, minarets, single figures, groups, heads, doors, windows, details of clothing, camels, colour notes, all the exhilarating and picturesque life of the towns and streets, mosques, houses, markets and desert. Scattered through the book wherever there was a few spare centimetres of space are myriads of miraculously tiny boats, some with a hairline network of intricate rigging, some with flying spars and graceful bird-like sails, some at rest, some leaning against a gentle breeze, some scudding across the water. A single page, 5" x 8", contains four studies of heads and nineteen boats, another has two landscapes, a view of a town, three figure studies, two heads and eight boats; everything throughout the book is observed with fascination and drawn with exquisitely delicate precision.

The surviving sketchbook, containing 191 pages, seems to have remained in the hands of Sir Thomas Phillips; but it is also recorded that Dadd had another book with him in Bethlem which lasted at least until 1878, possibly for the rest of his life. It is from this missing book, as well as from his remarkable visual memory, that he obtained so many of the ideas, details and sometimes complete scenes which became familiar in his work over the years but which are never exactly repeated. Pebbled rocky foregrounds dotted with scrubby plants from Palestine, eastern Mediterranean landscapes, houses and harbours clinging round the foothills of mountains, snowcapped peaks, high crags and vertical rock faces, all recognisably have their origins in the sketchbook, as well as views such as *Venice* which are specifically noted as having been worked up from sketches and compositions with Middle Eastern subjects and figures.

Few of Dadd's works, however, have a recognisably Egyptian content, and there is a paucity of Egyptian material in the Victoria and Albert sketchbook. Possibly the material

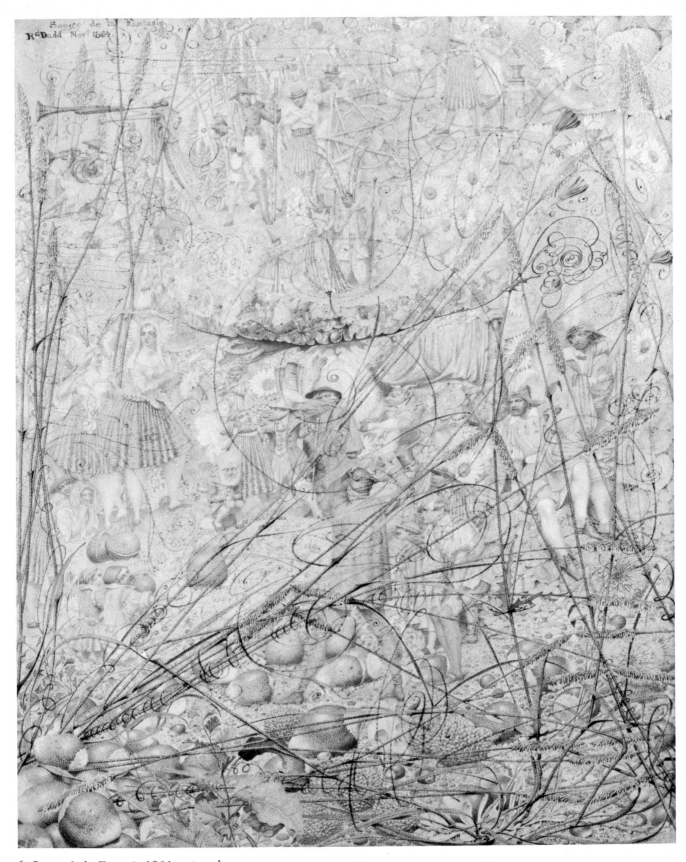

6. *Songe de la Fantasie* 1864, watercolour

was lost but it could also be that he did not achieve very much during the period around Christmas, 1842, when they were travelling up the Nile on the English consul's comfortable boat which Sir Thomas had hired for a month. Although the travelling was luxurious by any standards and especially after the hardships and exhaustion of Palestine, it was here that he suffered the first episode in an illness which was soon to shake his mental stability and finally to destroy his reason altogether. It was put down at the time to sunstroke and this may have played a part in triggering off the disorder, to which, however, he had a strong hereditary predisposition. (Of the seven children of Robert Dadd's first marriage three, Richard, George and Maria, were to become completely insane, while Stephen had 'a private attendant', though little more is known of his circumstances.) Dadd's illness cannot now be diagnosed, but symptomatic were a confusion of thought and a complete change of personality, associated with delusions which came to fill his mind with terrifying force. Beginning with an indefinable feeling of oppression, alternating with periods of excitement during which he could not work but walked feverishly about the streets of Alexandria drinking in the sights and sounds, or lay down at night 'with my imagination so full of wild vagaries that at times I have really and truly doubted of my own sanity', he gradually came to feel that he was being actively persecuted, and began to see the spirits disguised as ordinary men and women sent by the Devil to haunt and torment him. Most particularly, during the latter part of this journey, he discovered the Devil himself in the guise of Sir Thomas Phillips, though what he attempted to do about it is not recorded. For most of the time, he must still have been able to conceal his state of mind. They returned up the west coast of Italy, staying a month at Rome as originally planned, and it was not until they reached Paris at the end of May 1843, that he parted abruptly from Phillips, with expressions which left him with the gravest anxieties as to Dadd's sanity, and returned alone post haste to London.

At home it was quickly obvious to everyone that he was insane, though sunstroke was still held to be the cause. Until this time he had been a most attractive young man, gentle and affectionate towards family and friends and one of the most pleasant and cheerful of companions. Now he became nervy and suspicious, given to sudden, unaccountable and sometimes downright hostile actions, increasingly erratic and finally bizarre in his behaviour, and very occasionally confiding wildly to close friends about his intention to rid the world of the Devil.

In fact, as he recounted later, Dadd was rapidly being taken over by the idea that he was subject to the will of a superior being whom he identified as the Egyptian god Osiris. He was being prompted, whether by audible voices is not certain, toward actions which he knew would be regarded as insane by the rest of the world and which he concealed and resisted doing for as long as possible. His own account of events is vague and generalised and his mental confusion was obviously more pervasive than it would suggest, but somewhere at the core of his ideas was the notion that certain people were possessed by evil spirits and that he had a mission to destroy them.

While all this went on in the summer of 1843, he continued to work; and as well as the hastily executed entry for the competition to decorate the new Palace of Westminster, he completed a number of other pictures which 'strange to say . . . are as admirable in design and execution as his earlier work'. One of these is the strange and lovely *Caravan Halted by the Seashore,* which was exhibited at the Liverpool Academy that year. This picture shows Dadd's sense of design at its most elegant, with an elaborately contrived pyramidal group curving away in a gentle crescent to follow the line of the shore. The restraint of the design, the soft colours and atmosphere of frozen calm, provide remarkable evidence of

7. Cobham Hall, Kent, engraving 1843

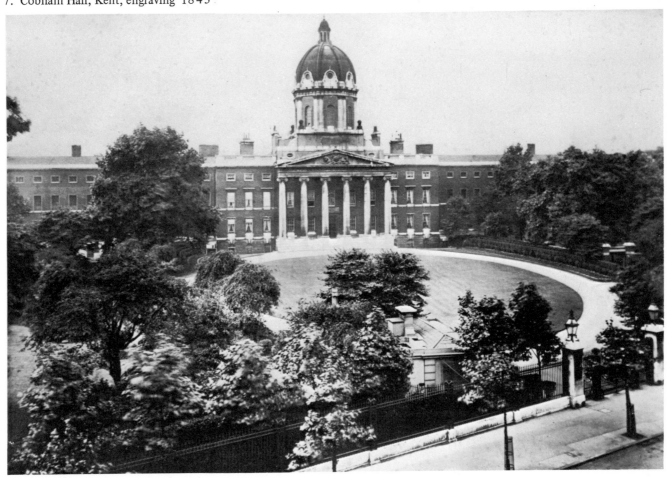

8. Bethlem Hospital, photograph c. 1920

the way in which his disciplined approach to painting held up through periods of the most acute mental distress and distortion.

Dadd's insanity seems never to have affected his technical ability in any way (except when it kept him from painting altogether) and only in the content of his work, and then infrequently, are there positive signs that his mind was not completely balanced. But only this one full-scale work has survived from the most critical period and one can only conclude that during the actual moments of painting he was in a state of relative peace, since other pictures from around this time did, apparently, show the signs which might be expected. An account of 1857 describes one watercolour painted after his return as 'a ghastly little invention of desert-horror, framed in by demons such as his distempered brain alone could devise'. This was presumably the *Dead Camel* shown at the Manchester *Art Treasures* exhibition, which also included *Artist's Halt in the Desert*, another watercolour having 'all the solemnity which the blue sky, and broad pale moon, and twinkling white stars are calculated to impress on an excited brain, calming its horror and lulling its rage to sleep'. Whether this is intended to prove that it did, or did not, show signs of insanity is a moot point.

Robert Dadd was naturally reluctant to acknowledge that his favourite and most favoured son could be going mad, and held that the effects of heat and over-exertion would be cured by rest and quiet. Eventually however he went for advice to Dr. Alexander Sutherland, physician to St. Luke's Hospital and one of the leading 'mad doctors' of the day. Sutherland's opinion was that Dadd was no longer responsible for his actions and must be watched constantly, but even now, very naturally, Robert Dadd could not bring himself to put his son under restraint.

By now Dadd had been persuaded by the 'secret admonitions' to which he was subjected that the man whom he had always regarded as his father was, in fact, the Devil, and under the same influence was secretly making careful plans to kill him. Two days after the consultation with Sutherland on 28 August he called at Suffolk Street and promised that if his father would come down to Cobham in Kent, a favourite childhood haunt where he had often sketched in Lord Darnley's estate of Cobham Park, he would 'unburden his mind'. After eating supper at the Ship Inn in Cobham and engaging beds in the village for the night, the two went out together for a walk and nothing more was heard of either until the following morning. Then Robert Dadd's body was discovered about thirty yards from the road in Cobham Park, on the edge of a deep hollow known as Paddock Hole (subsequently known as 'Dadd's Hole', but now filled in and no longer identifiable). He had been stabbed, after an attempt had been made to cut his throat with a razor, with a knife which his son had brought with him especially for the purpose.

Dadd had also equipped himself with a passport, and immediately left for France on the first leg of a journey in which he intended to exterminate more of the people possessed of the Devil. He was arrested near Fontainbleau after attempting to kill a complete stranger in a carriage who had not been on the original list, but who seems to have been pointed out to him on an *ad hoc* basis. Under French law he was transferred without standing trial to an asylum on being certified insane, and was eventually taken to Clermont where he remained until extradited the following July. It was never intended that he should be tried in England either, but the formalities had to be gone through with two preliminary hearings at the Rochester Magistrates' court, during which his behaviour left no doubt in anyone's mind as to his complete insanity. On 22 August 1844 he was transferred by warrant of the Home Secretary to the State Criminal Lunatic Asylum, then attached to Bethlem Hospital at St. George's Fields, Southwark.

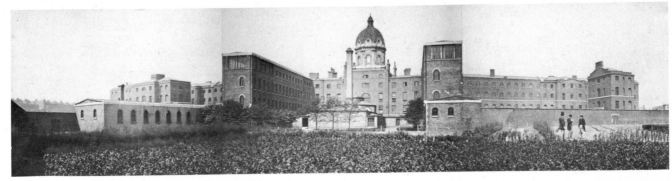

9. Bethlem Hospital, contemporary photograph

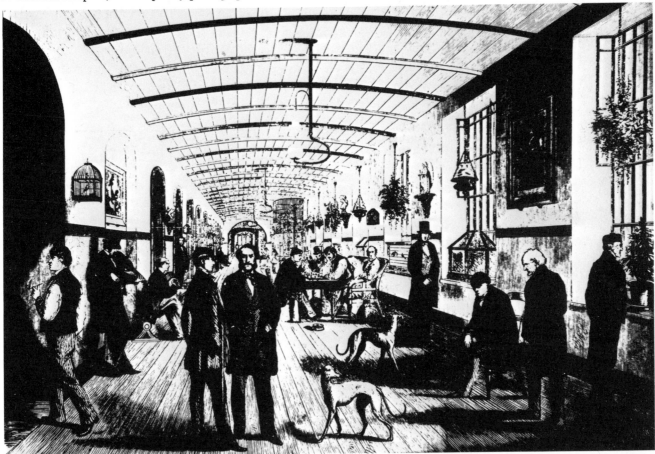

10. Ordinary ward at Bethlem, engraving c. 1860

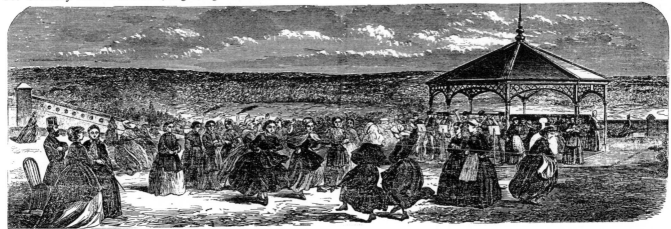

11. A female airing-court , Broadmoor Hospital, engraving 1857

Bethlem by now had been largely reformed from the conditions which had, in the eighteenth century, given the name 'Bedlam' its well-known connotations; but the male criminal block in which Dadd was confined was a separate unit, retaining all the prison-like characteristics which had been built into it in 1815. The space was limited and overcrowded and there were few facilities to separate the different categories of patient. Men such as Dadd who had committed one criminal act as a result of insanity in the course of an otherwise exemplary life were herded together with those who had long led lives of crime and degradation, until they finally became insane while serving sentences in the convict hulks and prisons. As described by the physician superintendent in 1855, 'the wards are dark, gloomy and inefficiently warmed — the windows are small and unnecessarily laden with iron bars, the staircases with iron gates . . . the absence of all workshops for occupation, and the scanty means of amusement at our disposal render the daily life of *all* the patients irksome . . .'

The wards were galleries about one-hundred feet long, lit only by a small heavily barred window at each end. Individual sleeping rooms opened off these, but the patients were kept together in their own particular gallery during the day except when allowed down to the exercise yard, a dreary featureless area enclosed by high walls. This was to be Dadd's total environment for the next thirteen years, until, in 1857, some forty of the 'better class' of criminal patients were moved into a specially converted ward in the main hospital. Here they were still isolated from the other patients, but inherited a great deal more light and space and also all the furnishings of aviaries, pictures, plants and statuary which had by that time been introduced throughout the hospital by the new and reforming physician superintendent, Dr. Charles Hood.

A description of Dadd at work in the 1850s tells of him 'weaving his fine fancies on the canvas amidst the most revolting conversation and the most brutal behaviour', so he must have painted in the crowded ward where everyone lived and ate throughout the day. It must be noted that his own conversation and behaviour was sometimes fairly unpleasant, particularly in the early days; but on the whole he did not associate much with the other patients, and as the years passed he became less subject to sudden and unpredictable impulses. His delusions, however, stayed fixed and immovable, though his intellectual capacity seems to have been practically untouched and he could always hold an intelligent and interesting conversation so long as it kept clear of the topics which excited him. As well as continuing to paint he kept up a professional interest in all the news he could glean of the art world outside. This probably filtered in more and more slowly as time wore on, and it is unlikely that he had any visitors from among his old acquaintances after one or two encounters during the first few years.

While in the French asylum Dadd had been sent brushes and canvas by his family, but he did not seem to recognise them nor to have any recollection of his past life. By 1845 he was at work again, and a description of his watercolours in this year says that they exhibited 'all the power, fancy, and judgement for which his works were eminent previous to his insanity'. They were mainly landscapes drawn from memory or from the sketchbook which he had with him; *View in the Island of Rhodes* and *Bethlehem* were probably among his otherwise lost group.

A small panel, *The Caravanserai at Mylasa*, is the only dated work from this period, and seems relatively straightforward. It has something of the frozen, static look characteristic of many of his pictures, but since this is to be found from the early fairy paintings on, it cannot be singled out as peculiar to the work of his insane period. There is also a slight strangeness in the way the figures are all arranged in full profile or full face or full back

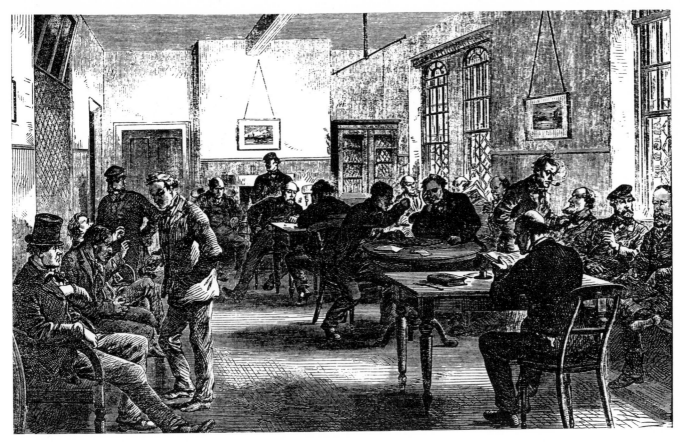

12. Day room for male patients, Broadmoor Hospital, engraving 1857

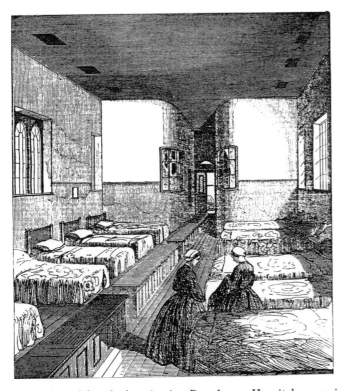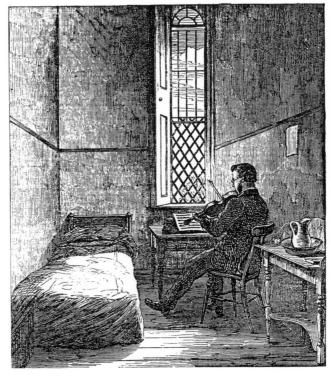

13. Male and female dormitories, Broadmoor Hospital, engraving 1857

view, and also in the two camels with their heads superimposed, a trick of confusing two images which Dadd often used later on and which probably seemed far more odd to his contemporaries than to those of us who have been conditioned by surrealism.

Until the early 1850s there is very little known work to judge from, but a report of 1848 describes him painting 'with all the poetry of imagination and the frenzy of insanity — in parts eminently beautiful, but other parts, in madness, without method.' The one surviving major work from 1849-50, *The Flight out of Egypt*, might well have been described in these terms. This fascinating, though confused and confusing, painting bears a striking superficial resemblance to Maclise's late frescoes and future work. But the various activities in different parts of the canvas seem wholly irreconcilable except in terms of the surface pattern which links them together, a feature quite alien to Maclise, and generally to Dadd too, even after he had become insane. In the very centre, beneath the obsessionally placed palm tree which halves the picture with disturbing exactitude, is a classic example of Dadd's superimposition of one image on another, the soldier whose face is completely obscured by the vessel he is drinking from. Despite its strangeness the picture is not wholly inaccessible, and there are passages of great beauty, particularly in the stream and rocky foreground, the colouring leftward from the soldiers, and in many individually fine figures.

It is always difficult to say where, apart from his sketchbook, Dadd got ideas, but he probably used visual material more freely in his early work than later on when pure imagination became the mainspring. A picture of *Fishwives* of 1849 appears to come from the unlikely source of a fishpaste pot lid, though few of his works can be pinned down so firmly to definite pictorial sources. Many of the subjects are illustrations of literary and historical stories, and most of the others can probably be classified under the generic name of 'fancy pictures'.

Among the watercolours, the most outstanding single inspiration sparked off the series of *Sketches to Illustrate the Passions* , which begins in 1853 and fades away during and after 1855. These figure compositions are all on paper about 14" x 10", realistic in style but imaginative in content. All thirty three have been identified by name, twenty seven of which have so far been traced. In these and similar figure compositions of the same period, Dadd shows his ability to handle controlled washes of colour in a style which is quite different from the intricately detailed miniaturism of so much of his work. *The Ballad Monger* is an outstanding example of this broader technique, and characteristically contains much very fine and delicate drawing. A number of these works are on brown paper and the colouring is nearly always low-keyed, tending often towards pinkish browns, ochres and blues but with touches of brighter local colour when the mood requires.

Some of the 'Passions' drawings are scenes from literature, mainly from Shakespeare, and the whole series is conceived in theatrical terms, the sketches presented as small scenes between a very limited number of protagonists. Some are violent in a way that the paintings never are. These generally include a dominant central figure with whom Dadd clearly identifies, performing some feat of aggression with wholehearted enthusiasm. Among these figure drawings one can also begin to recognise the strange, unfocused staring eyes which in some scenes may pass as mere exaggeration, but which cumulatively produce an effect which many people regard as Dadd's hallmark.

A few earlier watercolour figure studies have survived, but the main series was begun soon after Charles Hood (later Sir Charles) came to Bethlem as physician superintendent and swept through the hospital with reforming zeal that transformed the lives of its patients almost overnight. His interest in Dadd is apparent not only in the hospital's case notes — he

wrote of him as still able to be a very agreeable *companion,* a word which probably would not have entered his predecessor's vocabulary in speaking of a patient — but in the fact that at his death he owned thirty three of Dadd's pictures, including sixteen from the 'Passions'. One cannot say how far he actually influenced Dadd's choice of subjects or encouraged him to work, but on the present evidence the most productive period does seem to begin around the time of Hood's advent and the improved conditions which were the result. However, it should be borne in mind that much of Dadd's earlier work has undoubtedly disappeared, and Hood and others in the new regime may simply have made sure that it was more carefully preserved.

There is no doubt at all, however, that Dadd painted one of his two masterpieces for Dr. Hood and the other for Hood's colleague in reform and civilisation, the equally zealous young steward of the hospital, George Henry Haydon. These are the two fairy paintings, *Oberon and Titania* and *The Fairy Feller's Master-Stroke,* that bear Dadd's dedication to Hood and Haydon respectively.

So far as is known these two astonishing pictures mark Dadd's only return to fairy subjects after his illness, and although at first sight they seem worlds away from their prototypes of the 1840s, it is still possible to trace their development. This is particularly so with *Oberon and Titania,* which contains many similarities to *Puck* and *Titania Sleeping.* Here the Maclise-like design features are still very evident, now carried by Dadd's apparently limitless capacity for fantasy to extremes which push hard against the boundaries of credibility. The decorative border still surrounds the central area, the recessed alcove has become the very heart of the picture, the surface pattern takes on a degree of unfaltering complexity which defies analysis and the depiction of fine detail has been refined to a stage where the total interdependance between vision and technique achieves its mystical limit. It is a picture of which one knows with absolute certainty that it represents the perfect consummation of the painter's inspiration. The inventiveness of the design, by which the various groups of figures are supported within a deeply concave oval, on a series of outrageously improbable platforms, is almost lost in the incomparable ingenuity of the detail and the purity of its execution. Above all it is an entertaining, even playful picture — the last attribute one would expect to find in a painter oppressed by evil spirits and feelings of persecution. The foreground teems with microscopic creatures engaged in diverting activities, grasses have been tied in elaborate knots, dewdrops run down from the top of the picture and coat every surface, exquisitely incredible still-life contraptions find themselves at home amidst the leaves, and Titania herself perpetrates the ultimate joke, as she crushes a delicate flower together with its fairy occupant beneath her clumsy foot. The joke is very much at the expense of her diminutive forerunner, who nestled in a moonbeam in 1841.

Although it is fair to say that what the picture shows is obsessional, this differs chiefly in quantity rather than quality from that which any painter specialising in 'finish' might bring to his work. Not many could afford to spend four uninterrupted years on one painting at the level of concentration required to produce *Oberon and Titania,* though obviously this is not the whole story. *The Fairy Feller's Master-stroke* seems to come from a different level of consciousness; here the obsessionalism is not devoted to the finish, but is an essential part of the original act of creation. Some of the earlier stylistic features are preserved; the grasses form not a border round the work but a mesh across its surface, through which we have to peer as into a specimen box. Although the surface pattern is as subtle and intricate as anywhere in his work, it is the whole world which Dadd has created, in its entirety, which exerts such a mesmerising power and the details are not so much subordinate to this as totally inseparable from it.

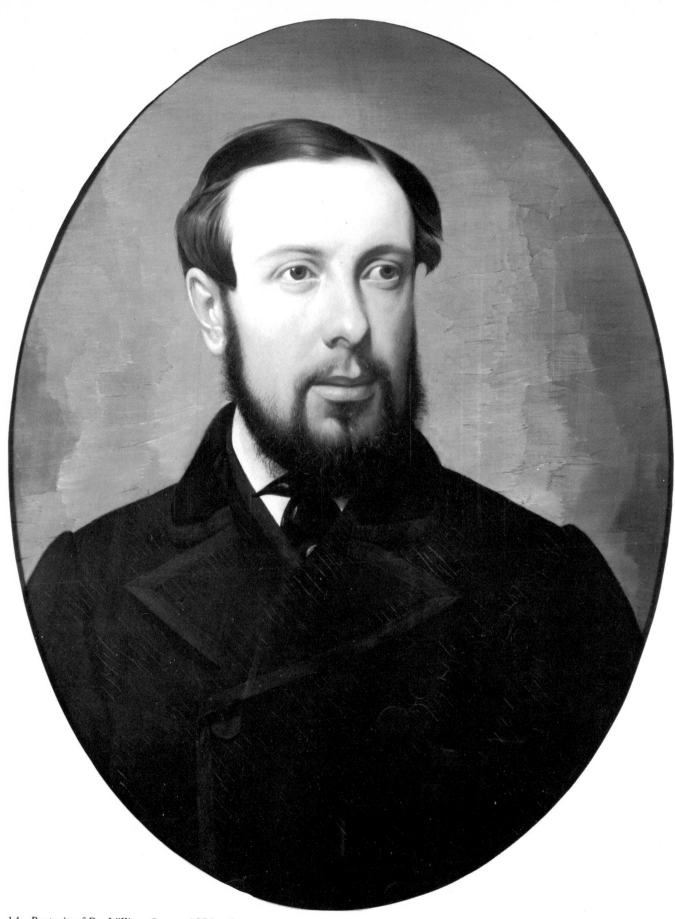

14. *Portrait of Dr. William Orange* 1875, oil on canvas

In a poem which he later wrote Dadd said that he stared for a long time at the blank canvas and could think of nothing to put on it, but that gradually the characters assembled of their own accord. Not that they drifted in casually; each one physically materialised by the sheer force of sharply focussed observation into his exact place within the total microcosm. The microcosm is itself held together by the intense and self-absorbed concentration of its inhabitants — there is no movement and no possibility of movement, no before or after, the figures are held in a trancelike stillness. The difference between the two pictures is partly exemplified in the fact that *Oberon and Titania,* despite the brilliance of its overall design, also cries out to be explored centimetre by centimetre; but it is virtually impossible to reproduce a detail from *The Fairy Feller* without falsifying both it and the entire picture.

Oberon and Titania took four years to complete; *The Fairy Feller* is dated 'quasi' 1855-64, which may mean that it was set aside during that period or that it took a long time to start; the only thing one can be certain of is that if Dadd wrote 'quasi' he meant something by it, for he was almost ritualistically careful about dating. Since it is not finished it must be assumed that he was working on it till he was moved to Broadmoor in 1864. At the beginning and end of this time he also produced other paintings of less complexity but equal quality. When looking at the two fairy subjects it is hard to imagine what else he might have painted and it is this air of finality about his work which makes each new discovery a revelation. In the magnificent *Saul and David* of 1854, the equally magnificent but quite different *Mother and Child* of 1860, *Negation* of the same year, the two magical shipping scenes of 1861 and the *Bacchanalian Scene* of 1862 he produced a definitive image, so complete that there is nothing left to spill over from one to another except the hallmark of his own intense vision. Although the same mark was beginning to be seen on the earliest fairy paintings, the works of his maturity bear the full stamp of uniqueness.

In his watercolour work it is easier to find chronological patterns and developments. After the 'Passions' sketches he seems to have turned back for awhile to landscape and then later to have used the technique developed for landscape in compositions containing figures. If *The Island of Rhodes* really is one of the 1845 watercolours, then the combination of stipple, wash and fine line in which it is painted must have been a method which he had always used for this sort of subject. It is certainly one of the finest examples known, the sun glinting from light-washed rock surfaces against purple stippled shadows, the pebbled plateau and carpeting grass picked out in gossamer lines. The broader figure studies then seem to have supervened for a time and the landscapes of 1857 onward have the appearance of a new departure.

From inscriptions it is clear that he was using his sketchbook and working up some original views, such as *Venice,* directly from it. The 'reminiscences' and the imaginary landscapes and seascapes seem to follow on naturally. Of these, *A Dream of Fancy* and *Port Stragglin* are representative of two slightly different approaches. The first, although a work of imagination, is a recognisable landscape, realistic in appearance, its essential qualities lying in its size and delicacy and the density of its vision. It is almost the opposite of the early fairy paintings, nature seen through the wrong end of a telescope rather than under a magnifying glass.

Port Stragglin is a distillation of purest poetic fantasy, a mystical town shimmering and fragile as a dream, its evanescence trapped and held down by the marvellous precision of the drawing. Though Dadd rarely reached quite such heights there is something of the same quality in many of the watercolours after the late 1850s, a sense of rapture in the creation of intricate form out of splintered fragments of light and line and colour. Looking at his

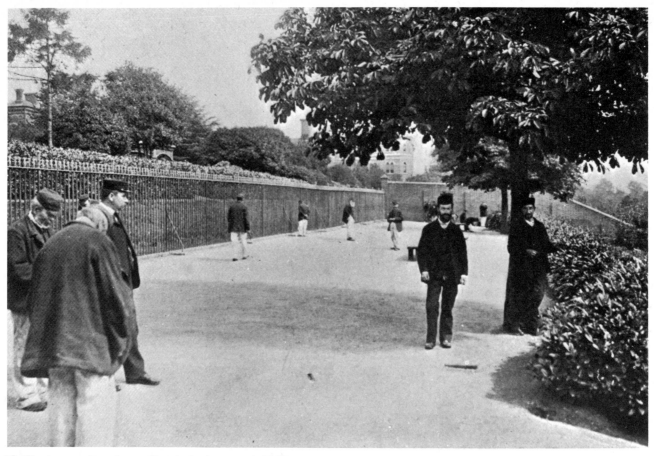

15. The terrace, Broadmoor Hospital, photograph 1908

16. *Water Nymphs* 1841, etching

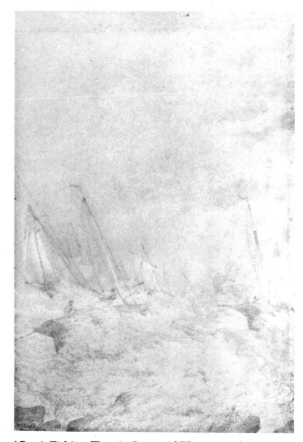

17. *A Fishing Fleet in Storm* 1877, watercolour

later watercolours one is inescapably reminded of Samuel Palmer's adjuration to himself in his notebooks: 'The visions of the soul, being perfect, are the only true standard by which nature must be tried . . . Sometimes landscape is seen as a vision, and then seems as fine as art; but this is seldom, and bits of nature are generally improved by being received into the soul . . .' For Dadd in Bethlem and Broadmoor, all landscape had passed through the refining fire of his soul.

In some ways the seascapes are the most remarkable of all, for ships and the sea symbolize the essence of freedom, a subject upon which it is dangerous to dwell in a state of lifelong imprisonment. To be able to paint seascapes after more than thirty years incarceration, presupposes a deep love which must have spent itself over the years in tormented craving; and yet in such works as *The Pilot Boat* and *Fishing Fleet in a Storm* it is sublimated into a lyrical tenderness which makes these little pictures amongst the most haunting, because the most haunted, of all Dadd's work.

In 1864 all the Bethlem criminal patients were transferred to the newly opened asylum at Broadmoor in Berkshire, where a great deal more freedom, occupation and amusement could be provided for them. By this time it could hardly have mattered much to Dadd, from the point of view of his work, where he was; though his physical comfort was very much improved, it is not surprising to find little immediate change, only a gradual progression along the path he was already treading. The one exception is the *Portrait of Dr. Orange* of 1875, a unique piece of realism which, even as a single response to a specific requirement, shows that he never lost the power to work in a vividly realistic style when the occasion demanded.

Little seems to have survived of his Broadmoor work, and although he painted more and more slowly over the years he must have produced more than the few pale dreamlike watercolours, the two Egyptian *Fantasies,* the portrait and *Wandering Musicians* — all that are known at present. But his major work here, which may have occupied him over a long period, has undoubtedly been largely destroyed. The men's recreation hall contained a stage and here Dadd painted scenery, a drop-curtain, which has lived vividly in the memory of former members of the staff, elaborately fanciful murals and, the only parts to survive, six panels from the front of the stage itself. He was also described, by a visitor who spoke with him in 1877, as having turned his hand to many forms of illustration and decoration, lantern slides and diagrams for lectures, comic figures at Christmastime, anything which the new and more varied way of life might throw up. The same visitor was also given a magnifying glass to examine a miniature on ivory, and since the tiny fishing boat scene, *Fishing Fleet in Storm,* is dated within a month of this visit, Dadd must surely have worked on other miniatures at some time during the final twenty-one years of his life in Broadmoor.

Richard Dadd died on 8 January 1886, and was buried in the cemetary at Broadmoor. The paintings and drawings which he left behind have been scattered and largely unknown for many years, and only now is their remarkable range and variety beginning to be appreciated. His work is always beautiful and often deeply moving, and the later watercolours in particular have a curious vulnerability, in front of which one hardly dares to breathe for fear of dispersing their magic. In aggregate it has a melancholy tone and many of his figures leave a wistful haunting image behind. With obvious exceptions, the lasting impression is, surprisingly, of a gentle spirit at work. But perhaps the one unique quality which shines through everything is the purity of a vision stripped, by the deprivation of external distractions and stimuli alike, down to the pale naked flame at its core.

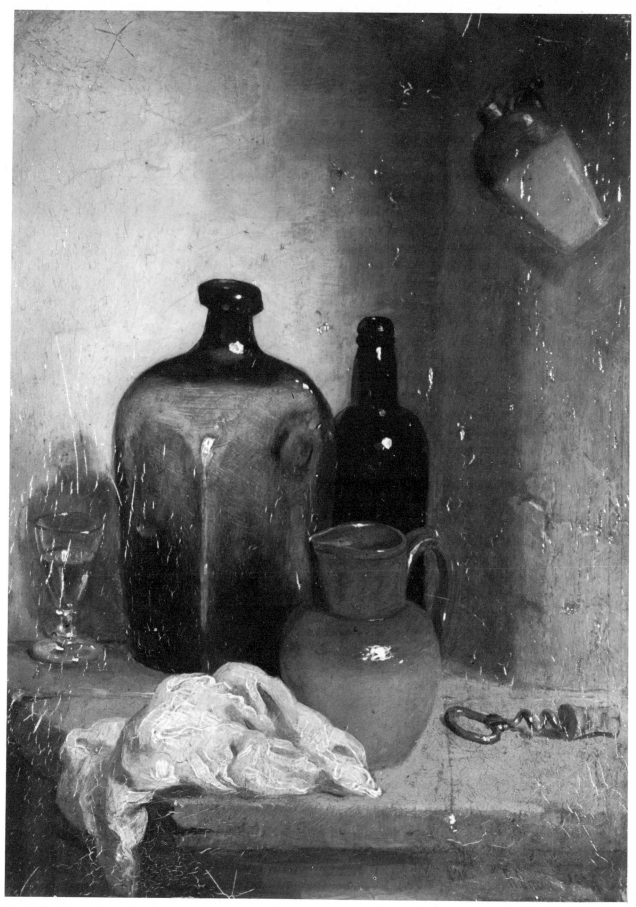

18. *Still Life with Bottles and Corkscrew* c. 1834, oil on board

19. *The Bridge* 1837, oil on board

20. *Landscape* 1837, oil on board

21. *A Country Churchyard* c. 1842, etching

22. *Figures in a Landscape* early 1830's watercolour

23. *Olive Grove at Athens* 1842, pencil

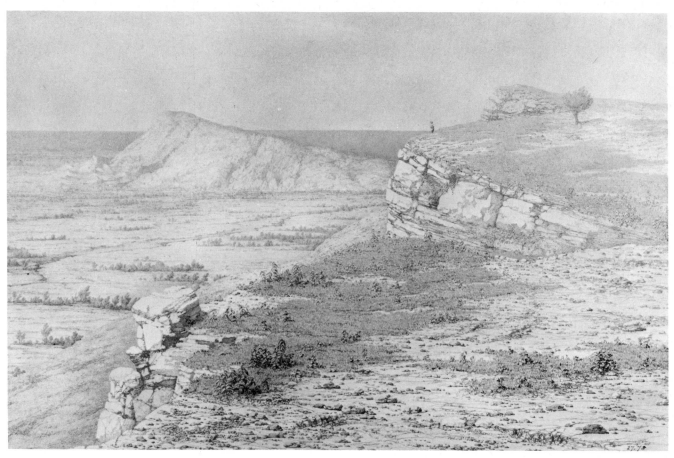

24. *View in the Island of Rhodes* c. 1845-1856, watercolour

25. *View on the Gulf of Corinth* 1842, pencil

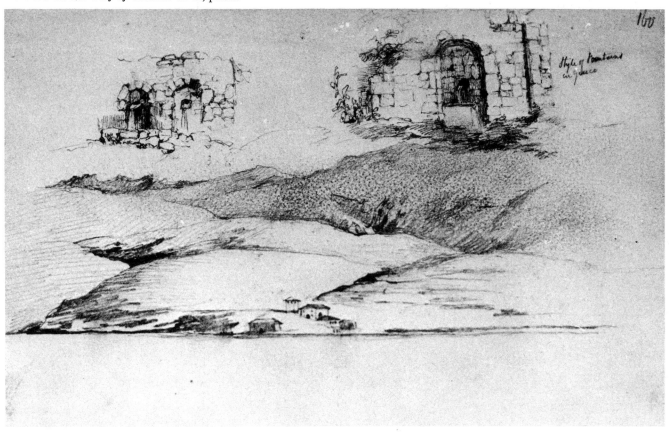

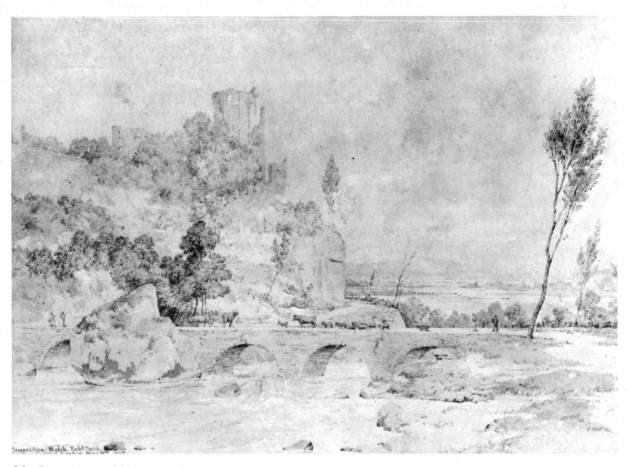

26. *Composition* 1857, watercolour
27. *A Dream of Fancy* 1859, watercolour

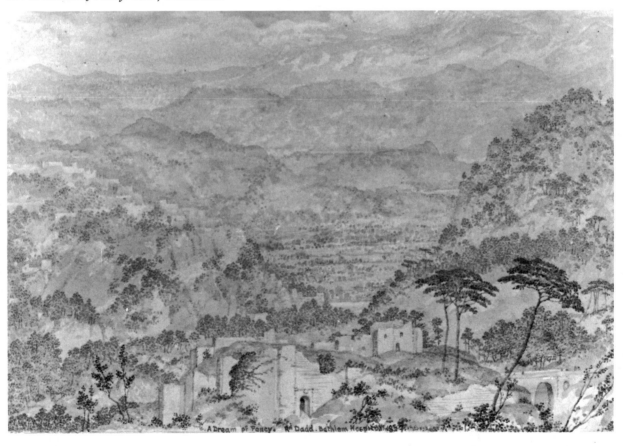

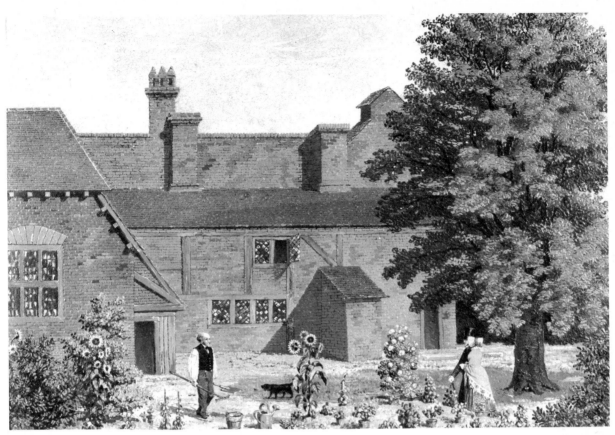

28. *Pope's House, Binfield* before 1864, oil on board

29. *Composition* 1873, watercolour

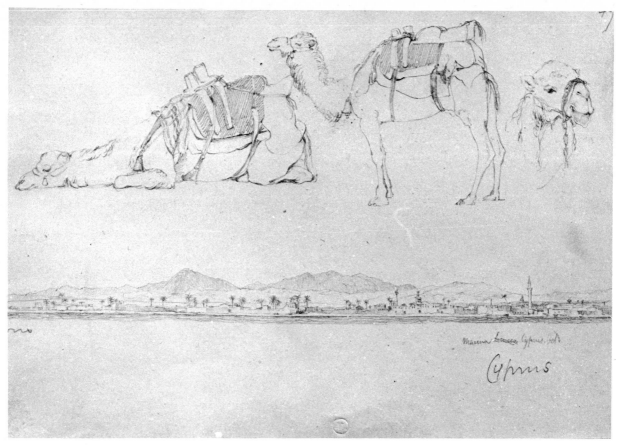

30. *Camels* and *The Coast of Cyprus* 1842, pencil
31-33. *Figure studies in Turkey and Syria* 1842, pencil

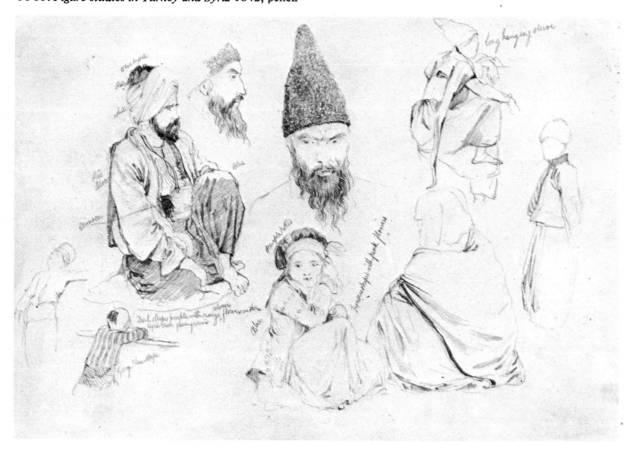

40

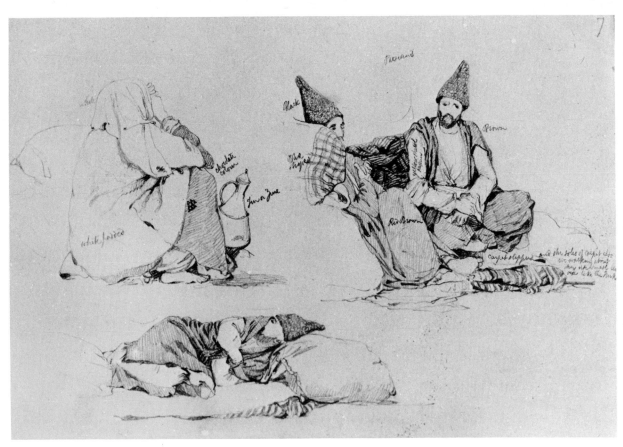

32-33. *Figure studies in Turkey and Syria* 1842, pencil

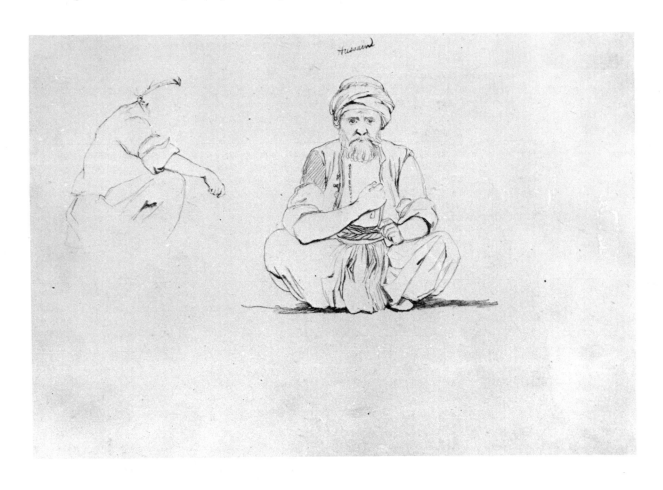

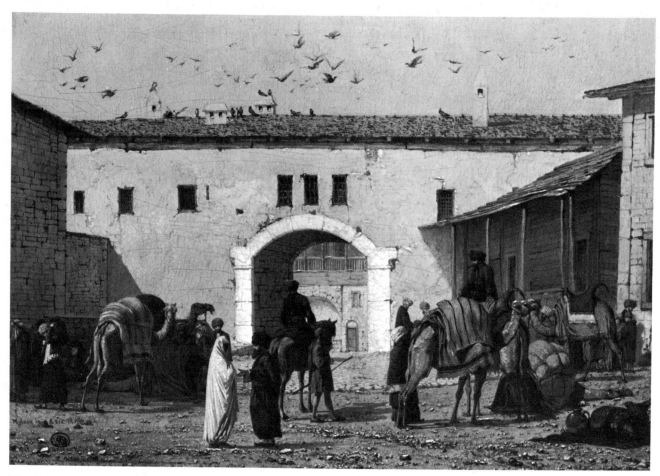

34. *Caravanserai at Mylasa in Asia Minor* 1845, oil on panel

35. *Arab Ambush* 1864, watercolour

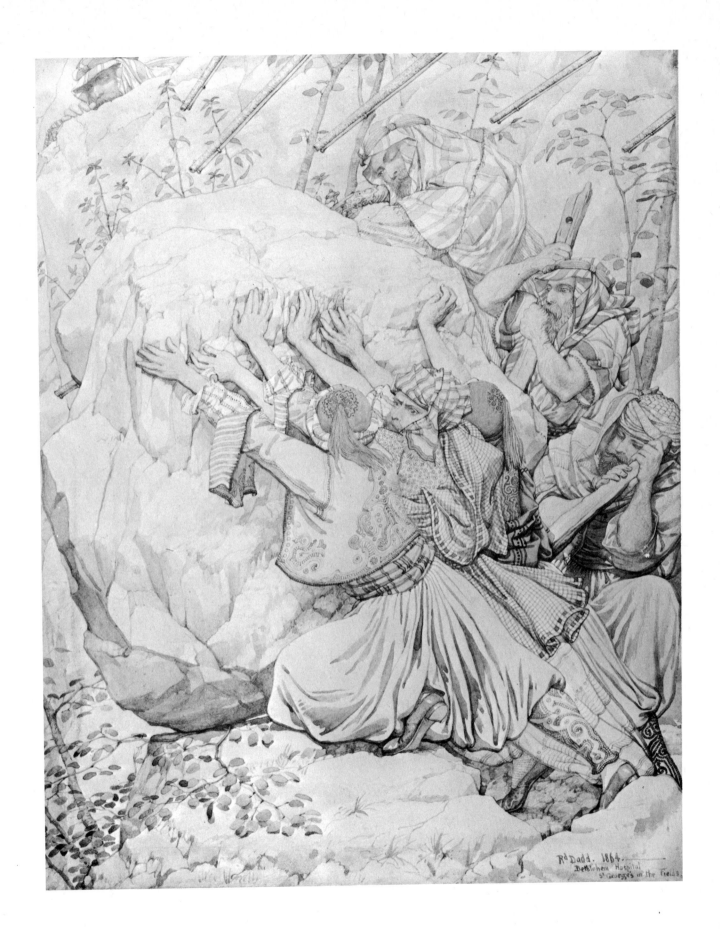

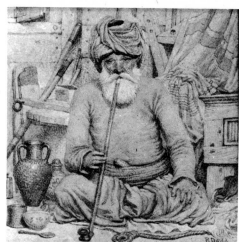

37. *A Turk* 1863, watercolour

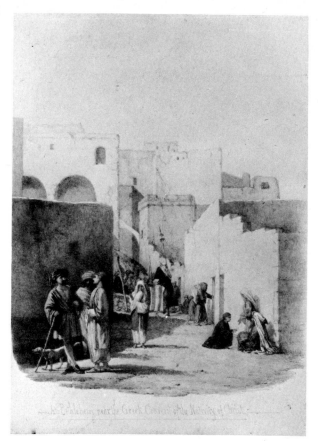

36. **Bethlehem near the Greek Convent of the Nativity of Christ** c. 1845, watercolour

39. *A Seated Arab* 1880, watercolour

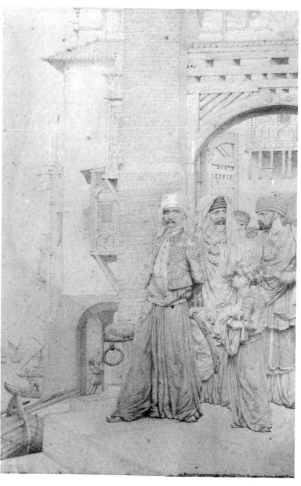

38. *Fantasie Egyptienne* 1865, watercolour

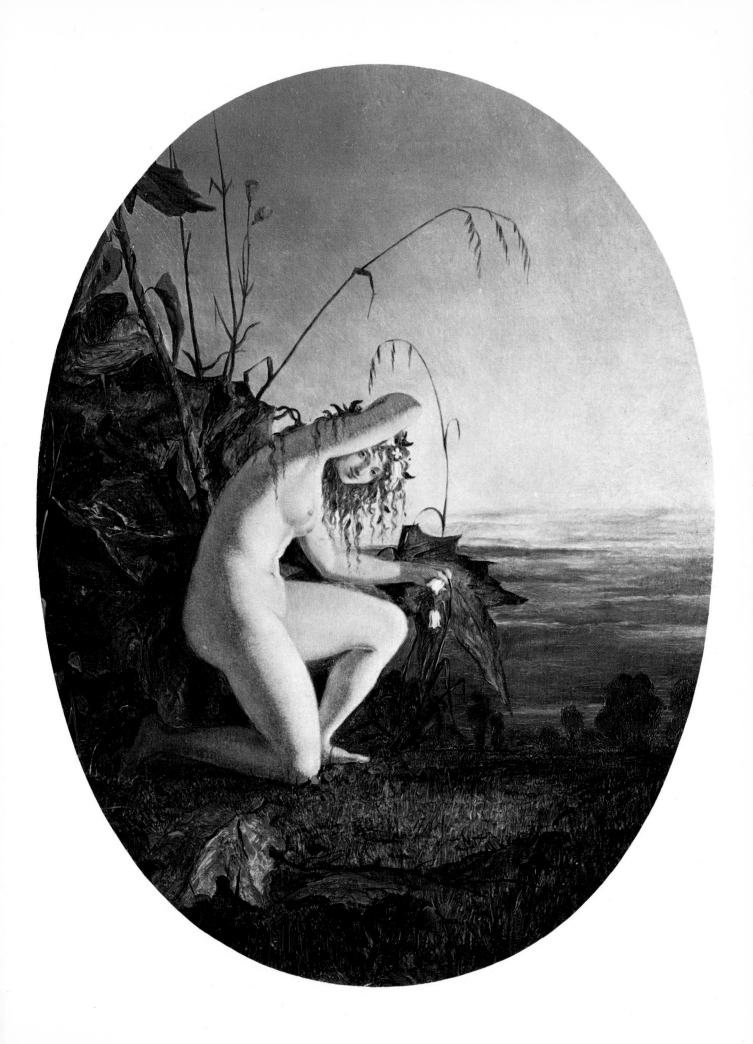

VI *Evening* c. 1841, oil on panel

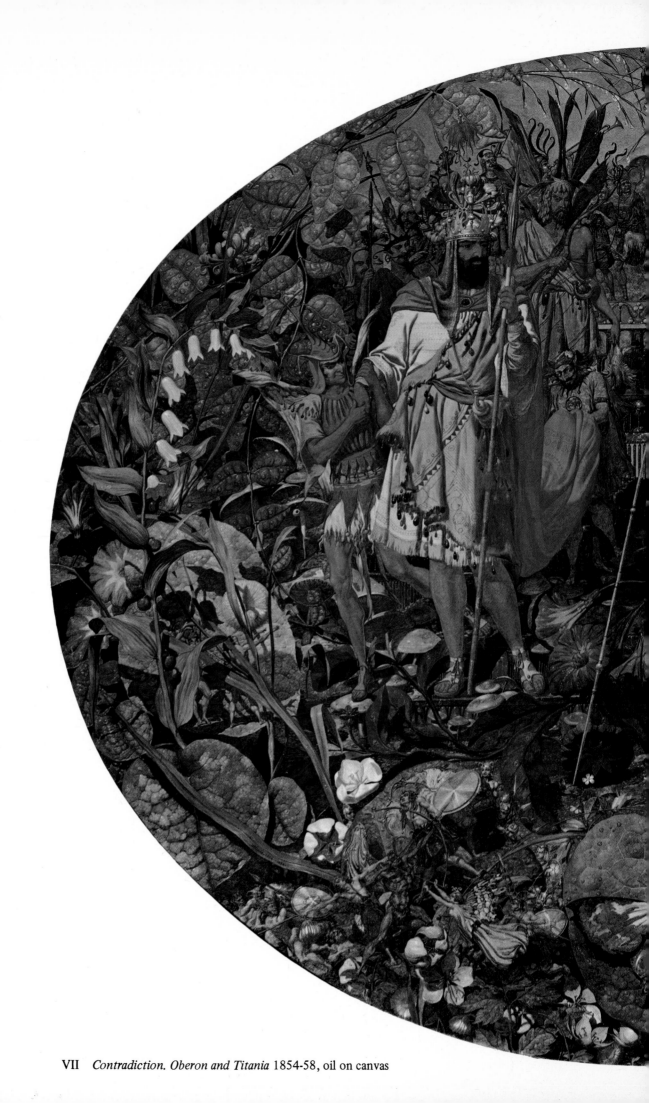

VII *Contradiction. Oberon and Titania* 1854-58, oil on canvas

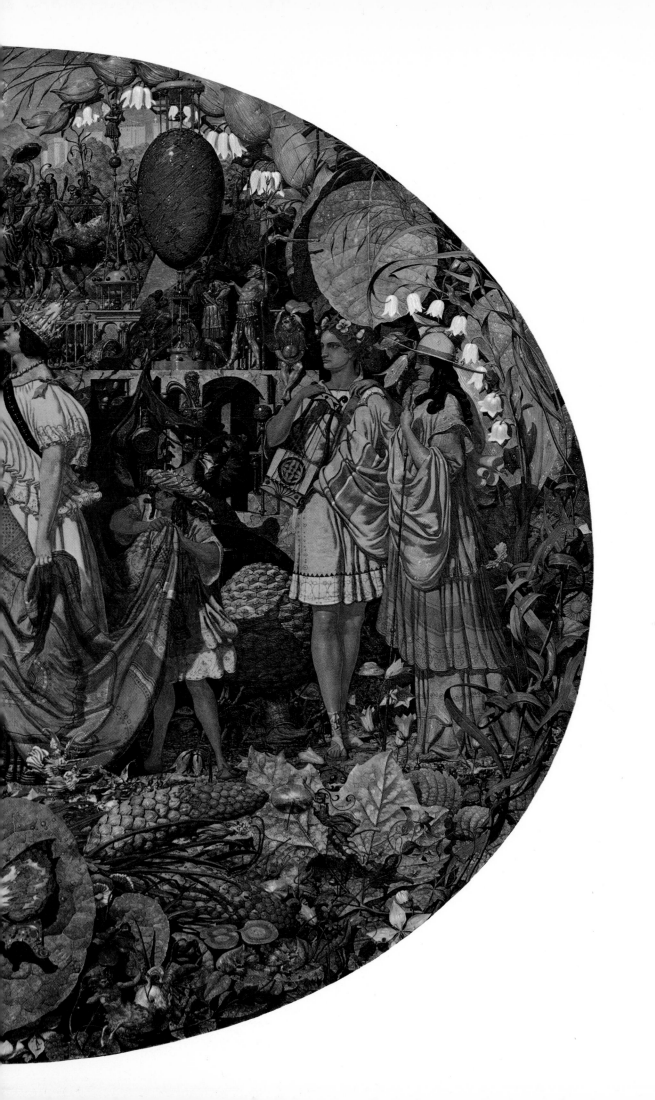

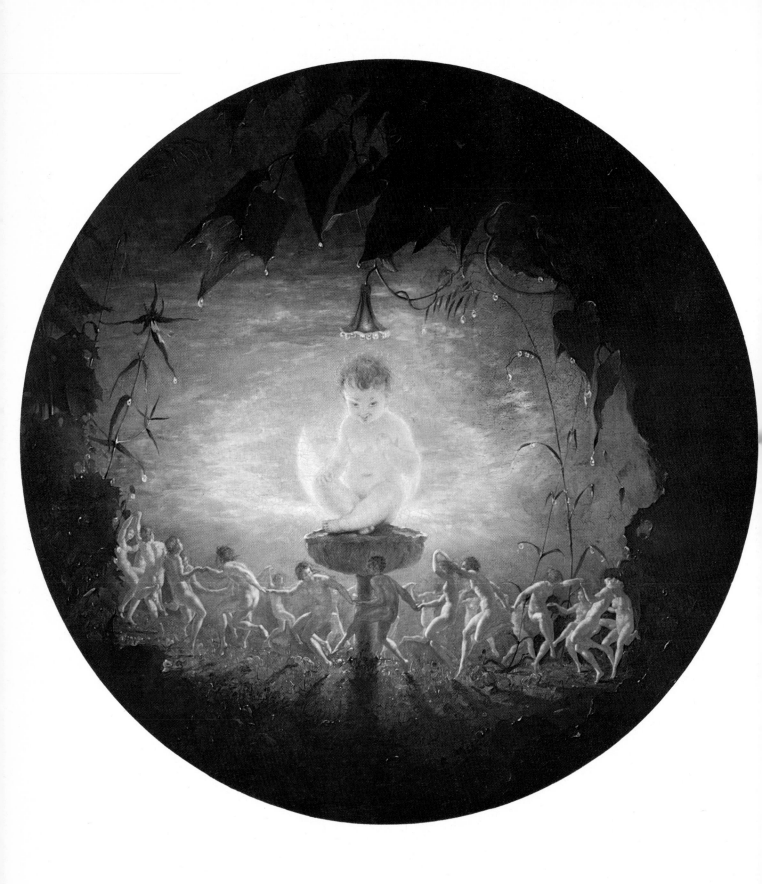

VIII *Puck* c. 1841, oil on canvas *(detail)*

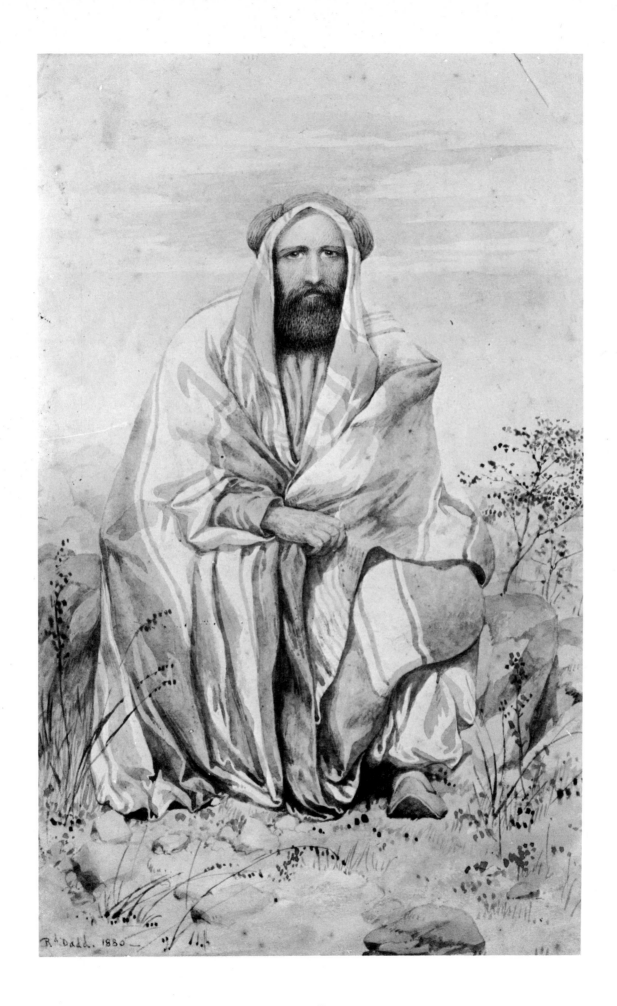

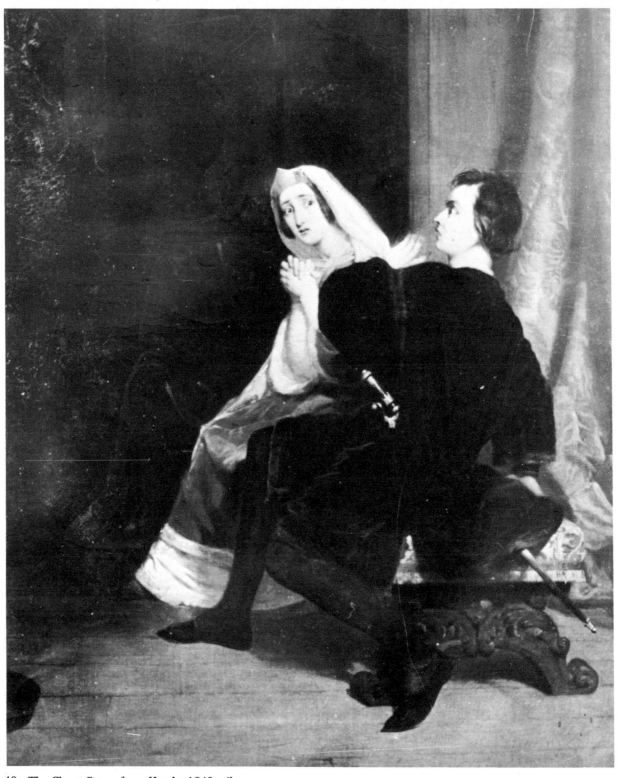

40. *The Closet Scene from Hamlet* 1840, oil on canvas

41. *Newhaven Fisherfolk* c. 1849, oil on canvas
42. *Sketch of Jesus Christ Walking on the Sea* 1852, watercolour

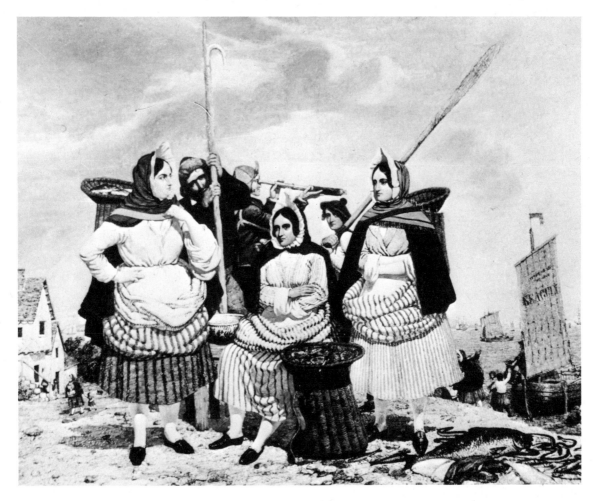

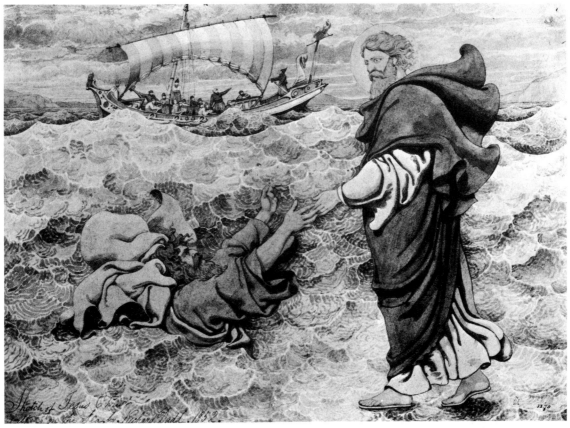

43. *Fishwives* 1849, oil on canvas

44. *The Ballad Monger. A Reminiscence* 1853, watercolour
45. *Sketch of Polyphemus Discovered Asleep by the Shepherds of Sicily* 1852, watercolour

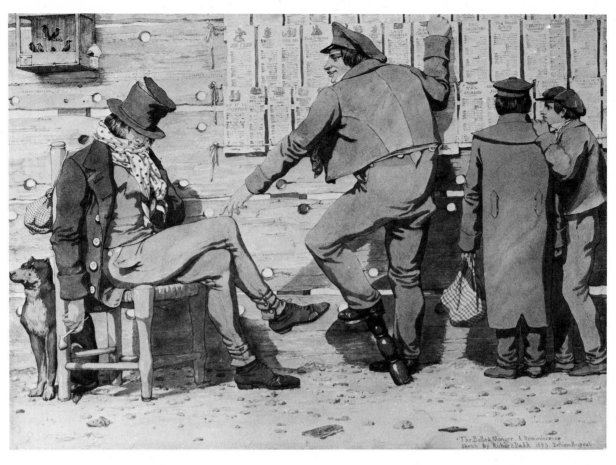

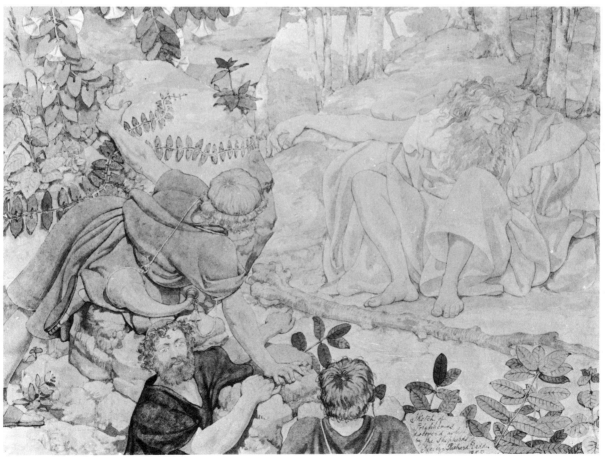

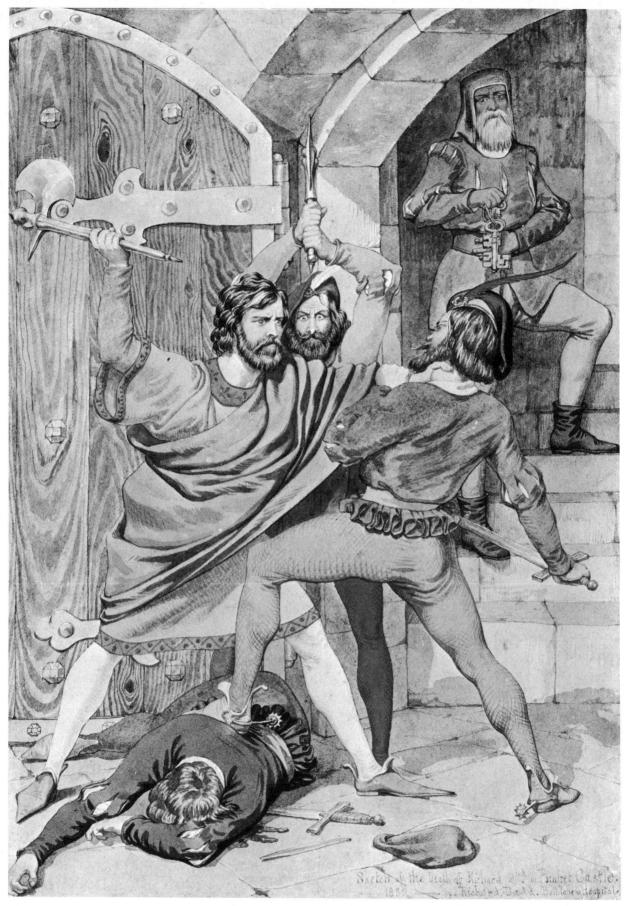

46. *Sketch of the Death of Richard II in Pomfret Castle* 1852, watercolour

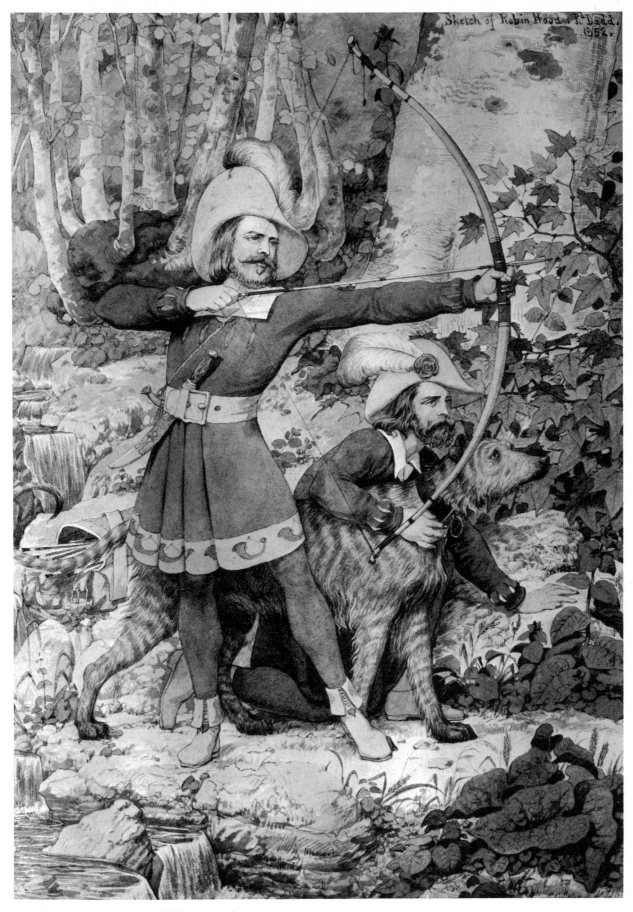

47. *Sketch of Robin Hood* 1852, watercolour

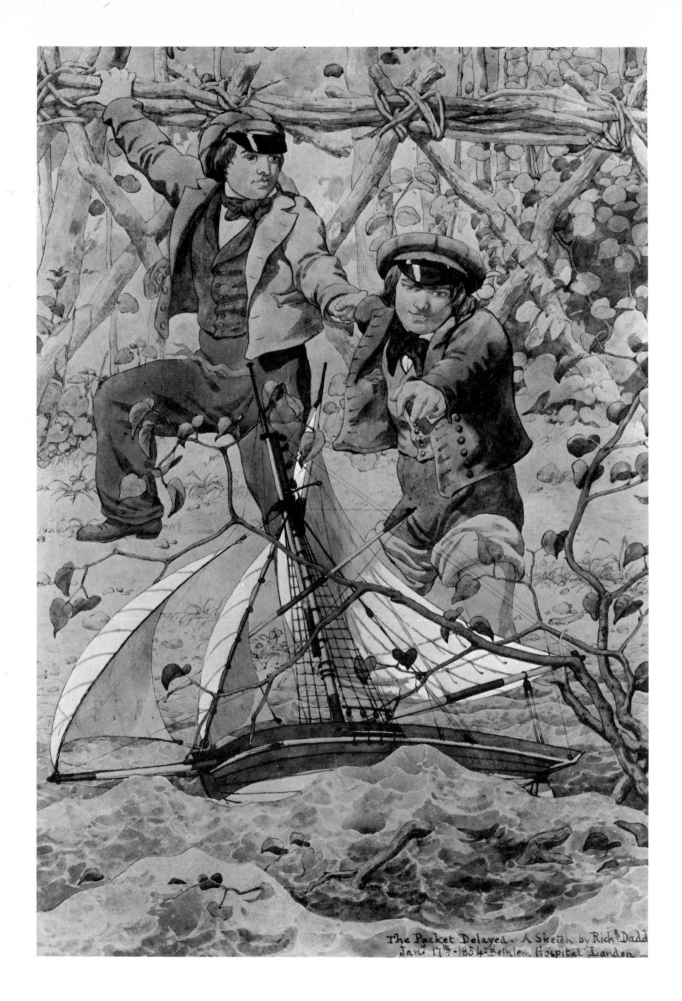

The Packet Delayed — A Sketch by Richd. Dadd
Jany 17th — 1854 — Bethlem Hospital London —

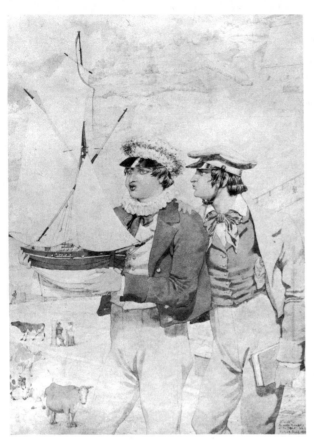 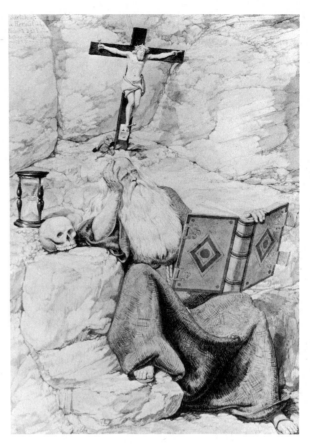

49. *Sketch of the Juvenile Members of the Yacht Club* 1853, watercolour

50. *Sketch of a Hermit* 1853, watercolour

48. *The Packet Delayed* 1854, watercolour

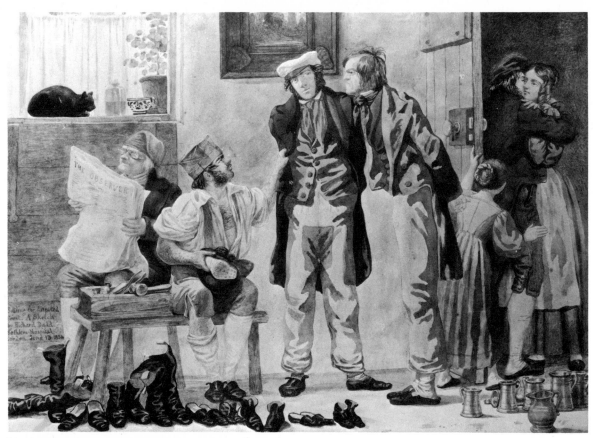

51. *Settling the Disputed Point* 1854, watercolour

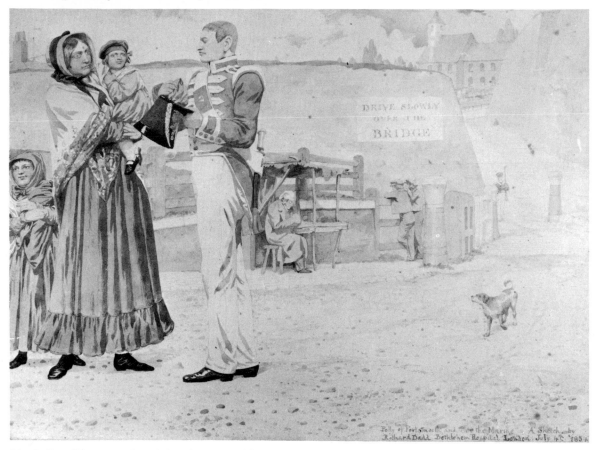

52. *Polly of Portsmouth and Joe the Marine* 1854, watercolour

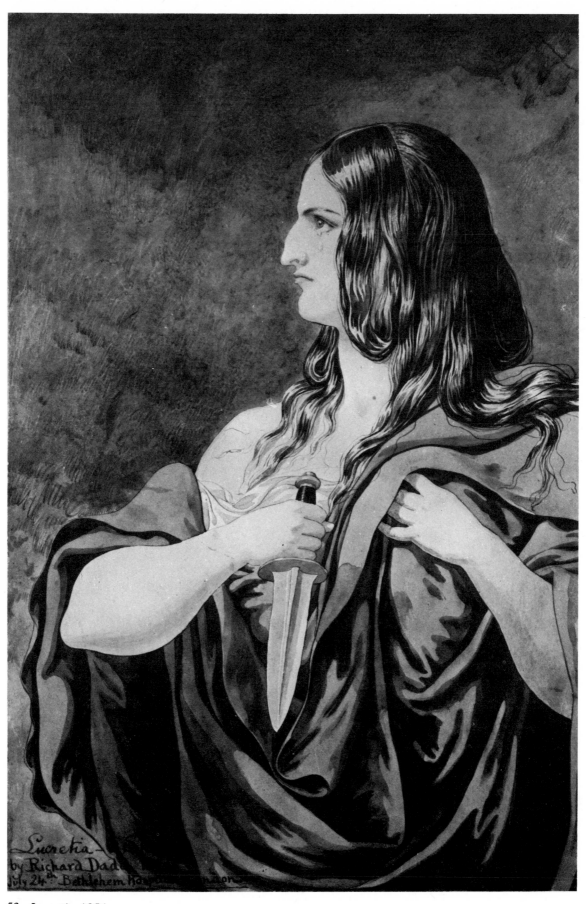

53. *Lucretia*, 1854

55. *The Child's Problem. A Fancy Sketch* 1857, watercolour

54. *Mercy. David spareth Saul's Life* 1854, oil on canvas

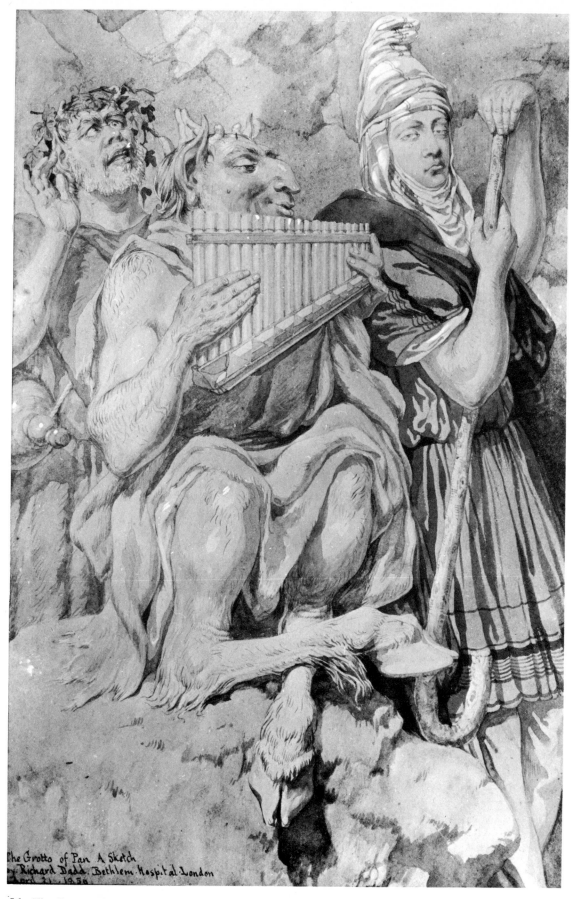

56. *The Grotto of Pan,* 1856, watercolour

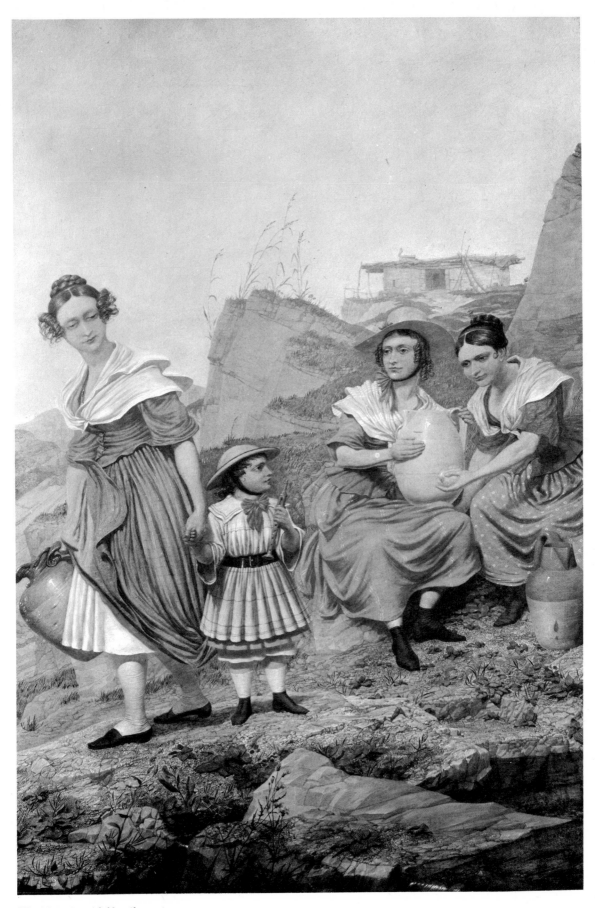

57. *Negation* 1860, oil on canvas

58. *The Crooked Path* 1866, watercolour

IX *Bacchanalian Scene* 1862, oil on canvas

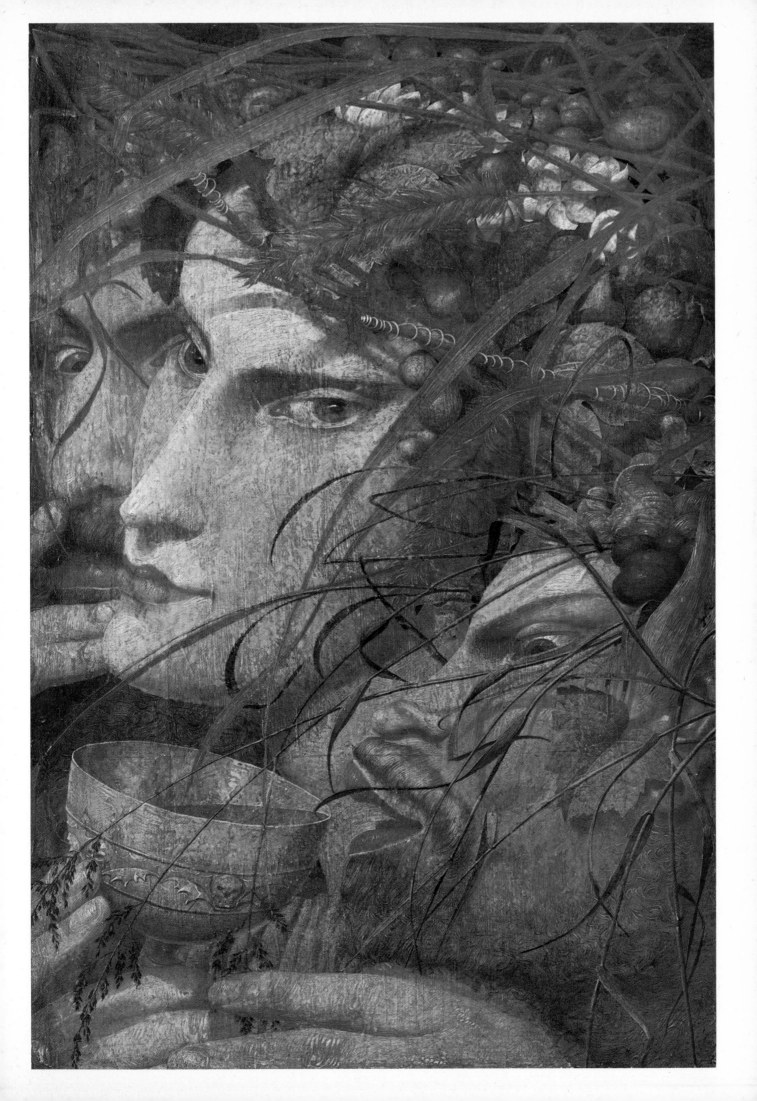

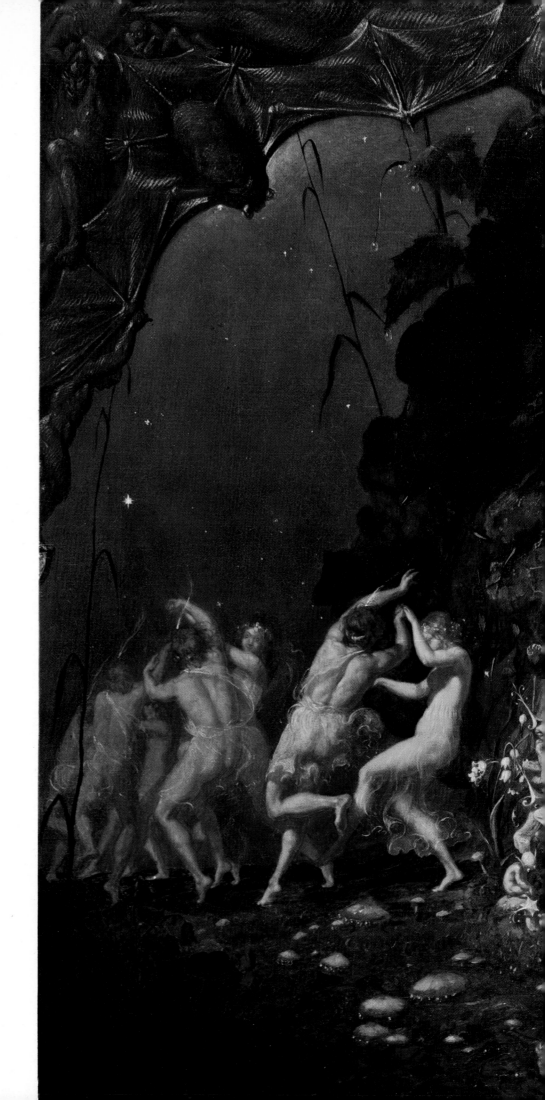

Previous page:
IX *Bacchanalian Scene* 1862,
oil on canvas

X *Titania Sleeping* 1841,
oil on canvas

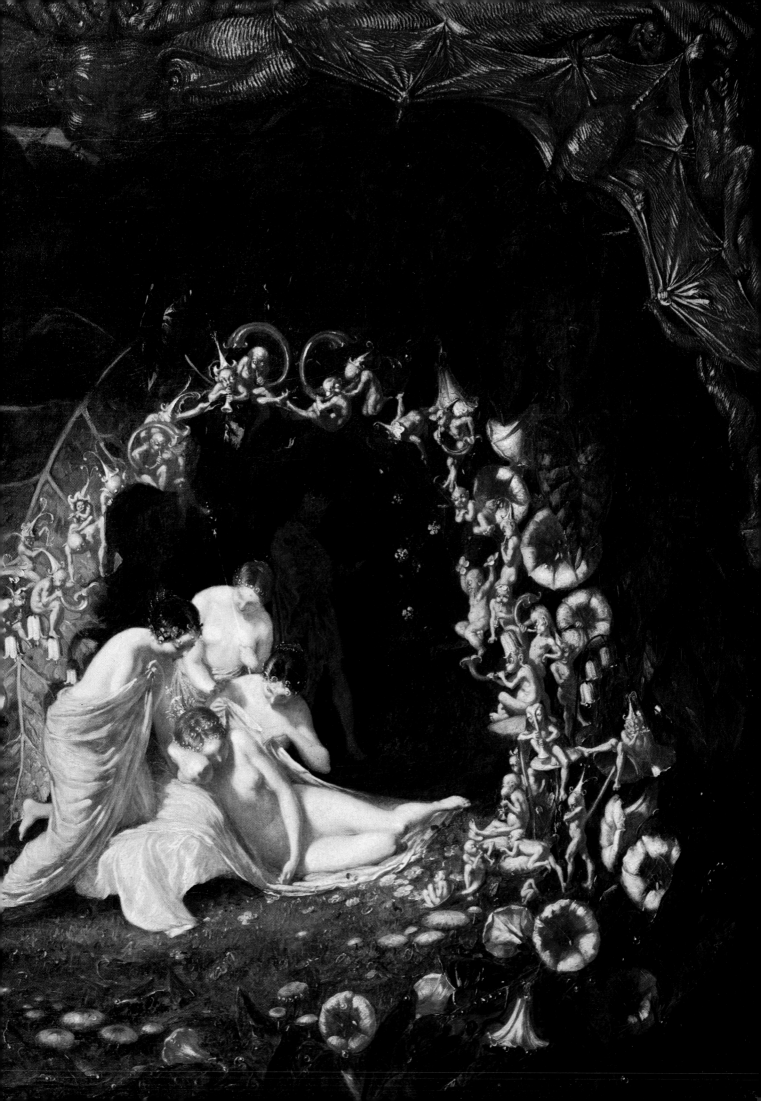

XI *Mother and Child* 1860, oil on canvas

59. *Wandering Musicians* c. 1878, oil on canvas

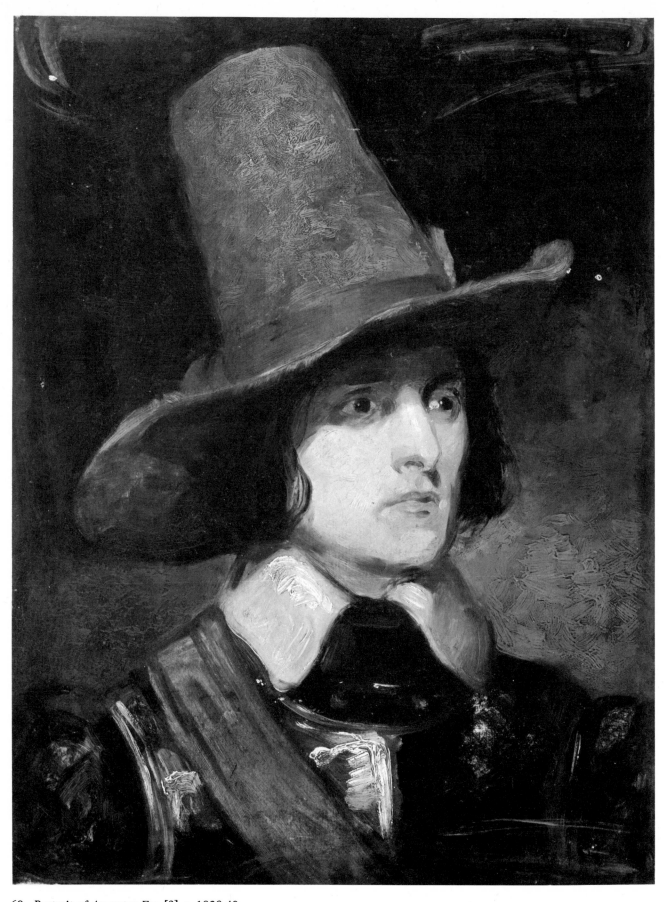

60. *Portrait of Augustus Egg* [?] c. 1838-40

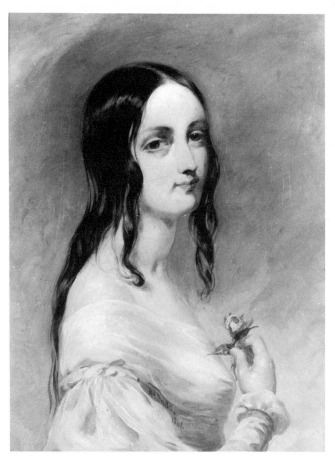

61. *Portrait of a Girl in a White Dress* 1841, oil on panel

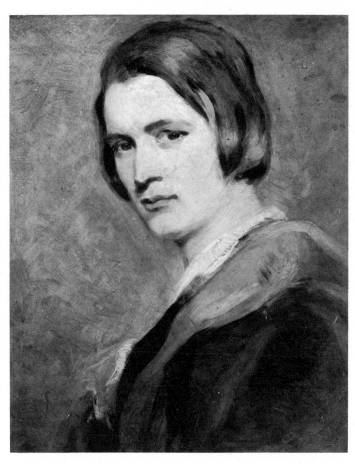

62. *Self Portrait* c. 1840, oil on panel

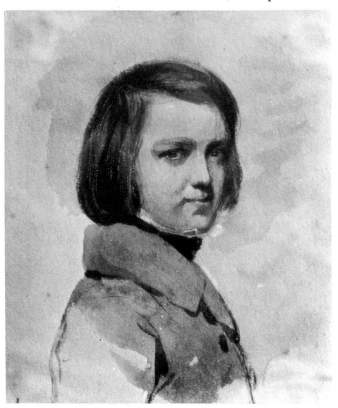

63. *Self Portrait* c. 1840, watercolour

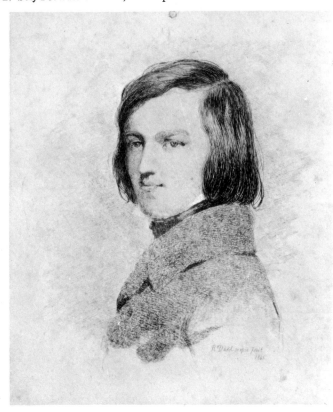

64. *Self Portrait* 1841, etching

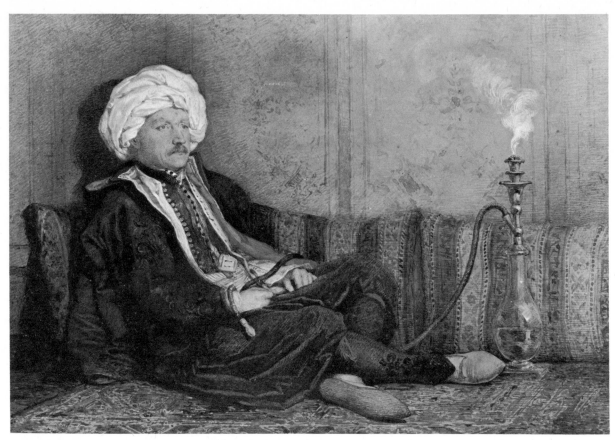

65. *Portrait of Sir Thomas Phillips in Eastern Costume, Reclining* 1842-1843, watercolour

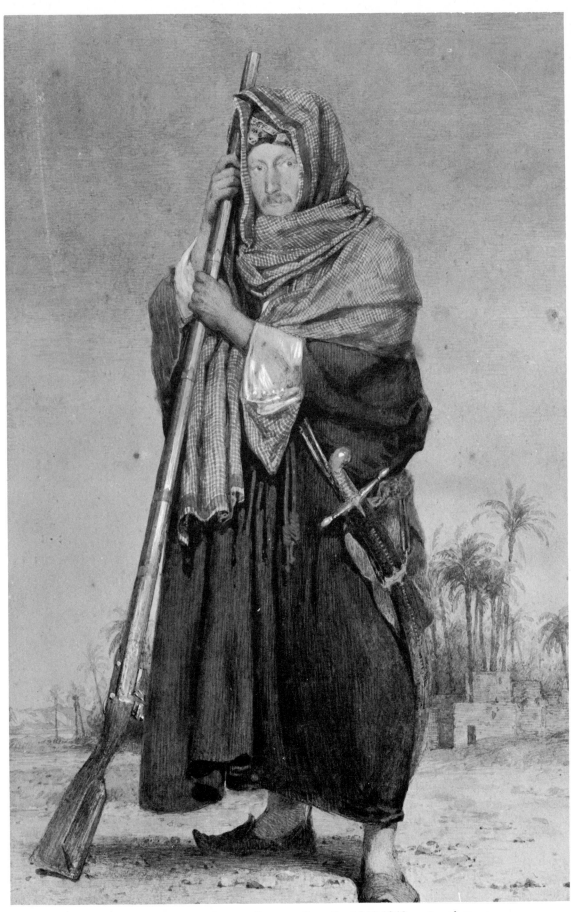

66. *Portrait of Sir Thomas Phillips in Eastern Costume, Standing* 1842-1843, watercolour

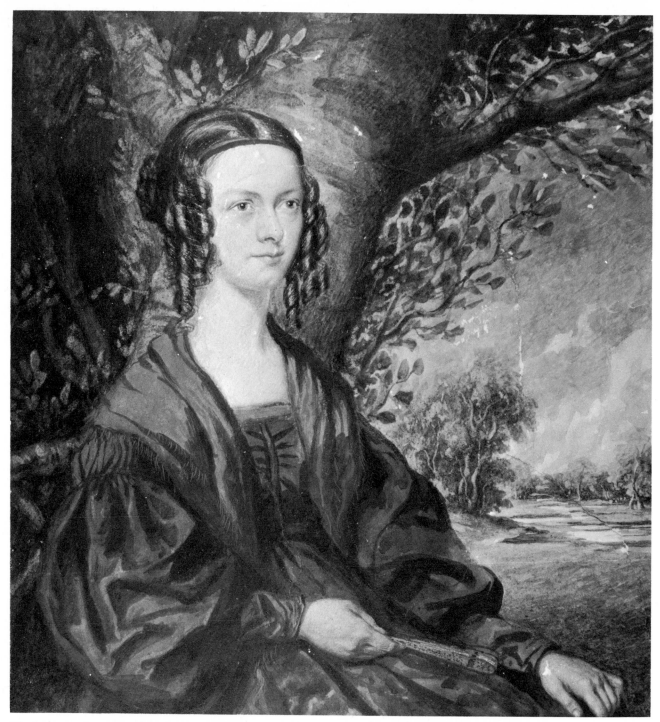

67. *Portrait of his Sister* [?] 1832, watercolour

68. *Portrait of a Young Man* 1853, oil on canvas

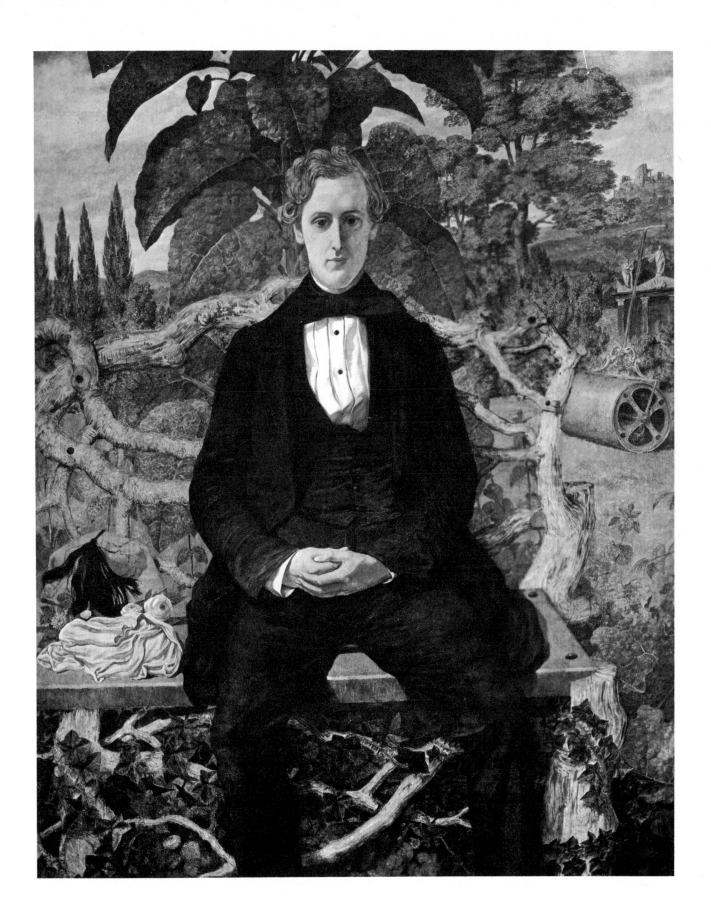

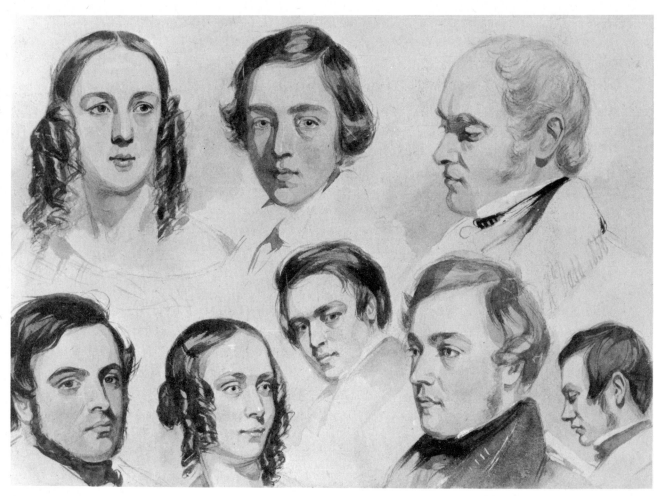

69. *Family Portraits* 1838, watercolour

70. *Columbine* 1854, watercolour

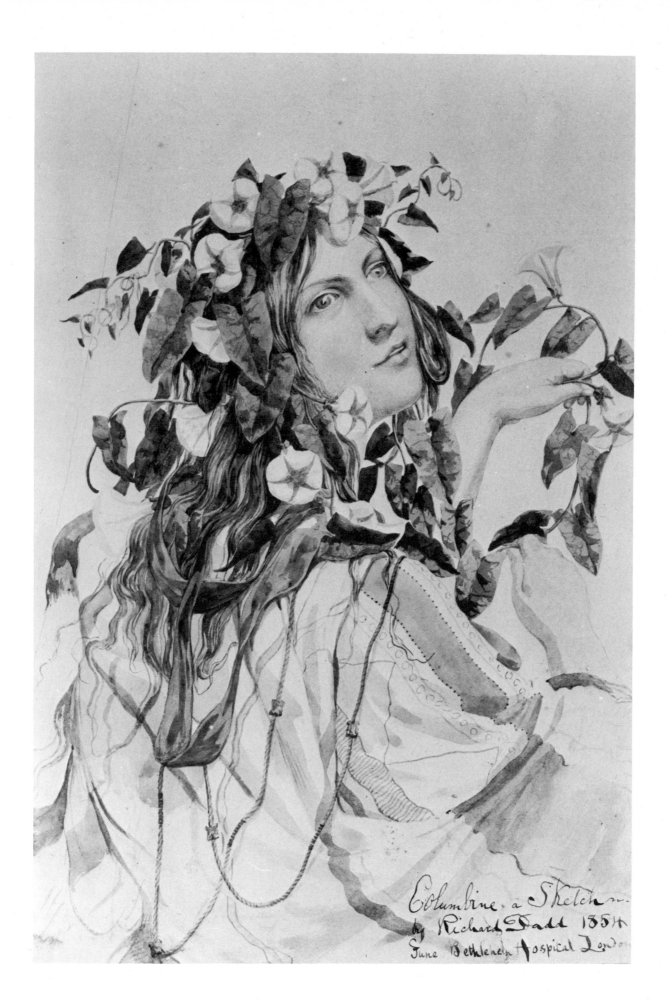

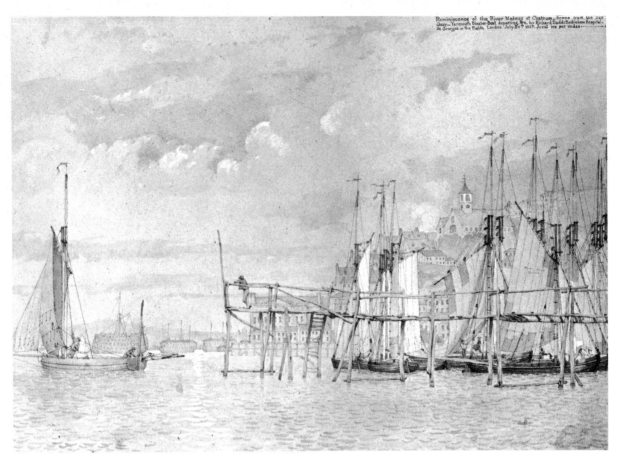

73. *Reminiscence of the River Medway at Chatham* 1857, watercolour

74. *Reminiscence of Venice* 1858, watercolour

71. *Boats* 1842-43, pencil

72. *Boats* 1842-43, pencil

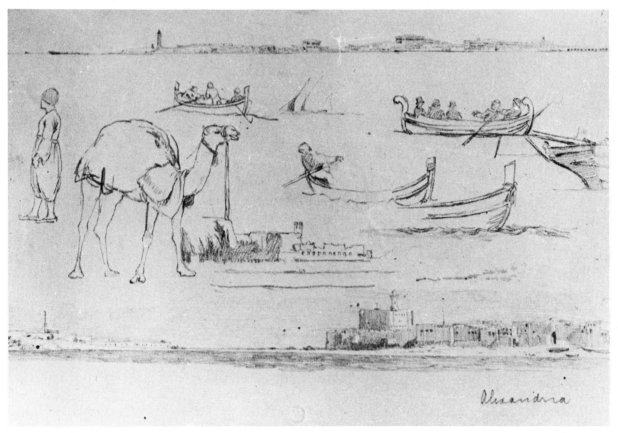

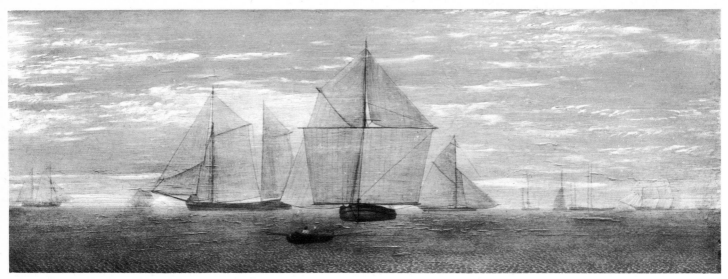

75. *Sailing Ships* 1861, oil on panel

76. *Shipping in a Fresh Breeze* no date, watercolour
77. *The Pilot Boat* 1858-9, watercolour

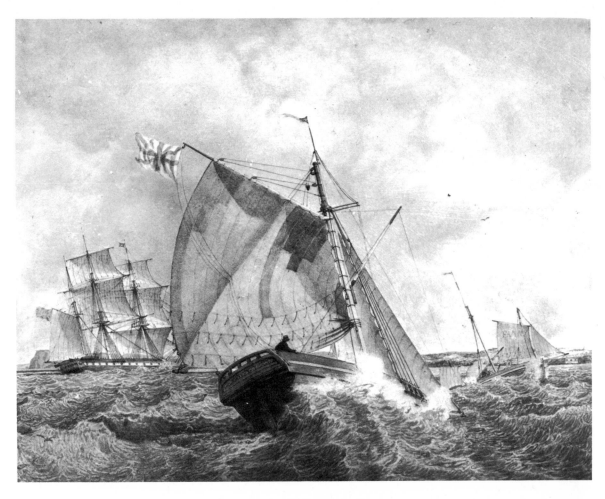

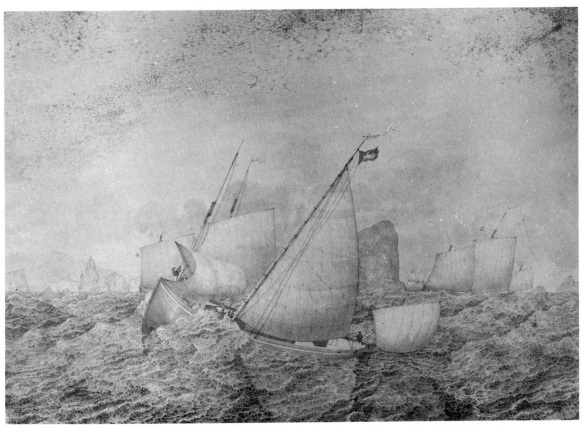

78. *Poverty* 1853, watercolour

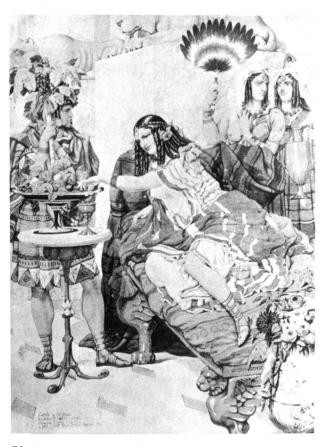

79. *Splendour and Wealth* 1853, watercolour

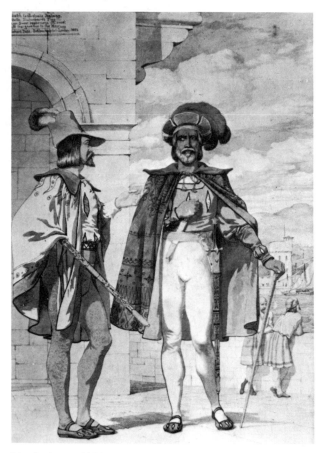

80. *Jealousy* 1853, watercolour

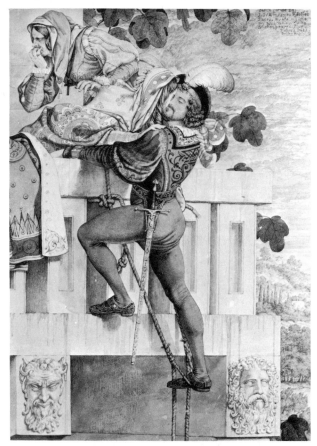

81. *Love* 1853, watercolour

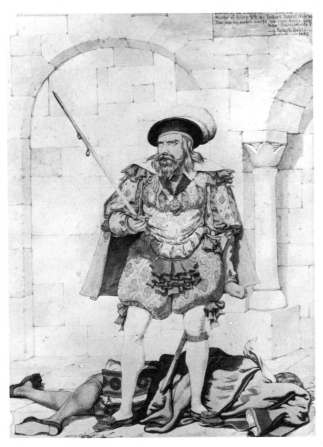

82. *Hatred* 1853, watercolour

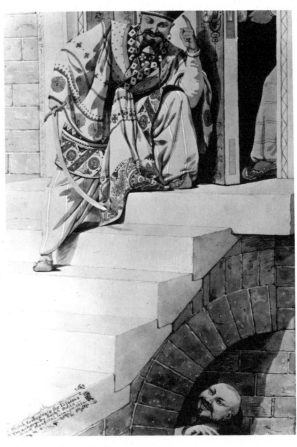

83. *Treachery* 1853, watercolour

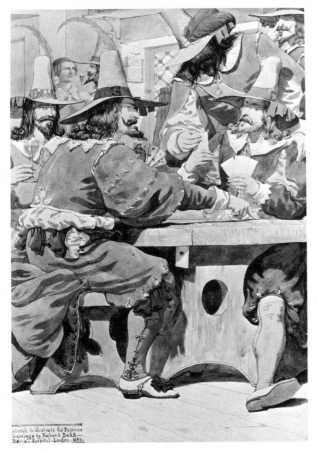

84. *Gaming* 1853, watercolour

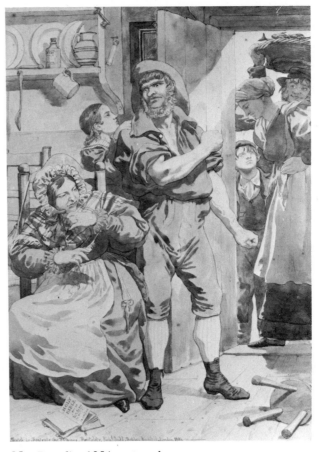

85. *Brutality* 1854, watercolour

86. *Ambition* 1854, watercolour

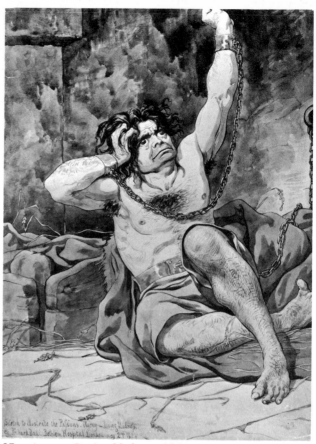

87. *Agony - Raving Madness* 1854, watercolour

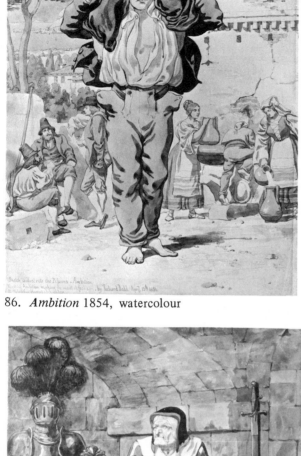

88. *Avarice* 1854, watercolour

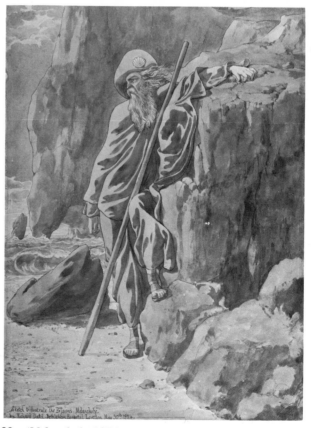

89. *Melancholy* 1854, watercolour

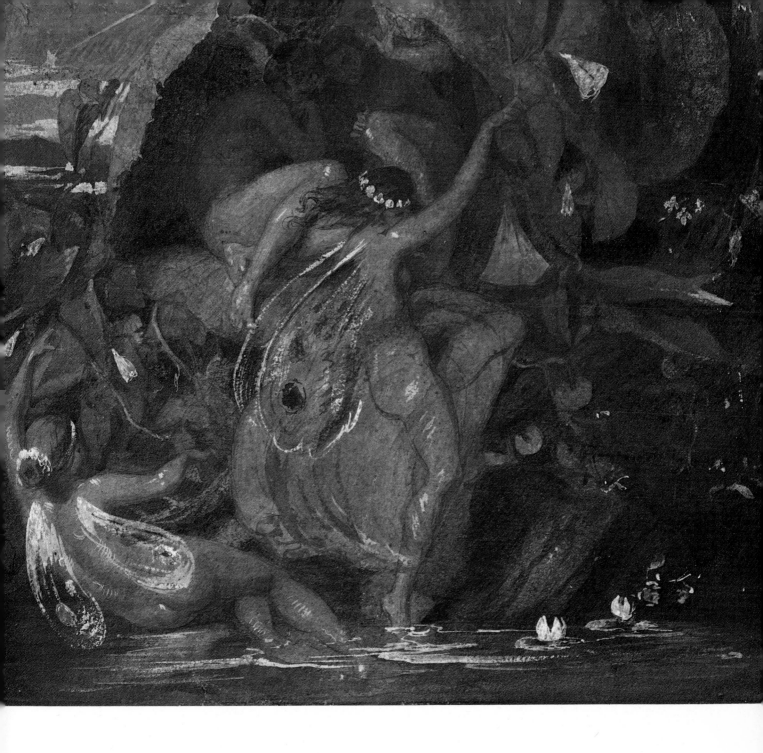

XII *The Fairys' Rendezvous* c. 1841, watercolour

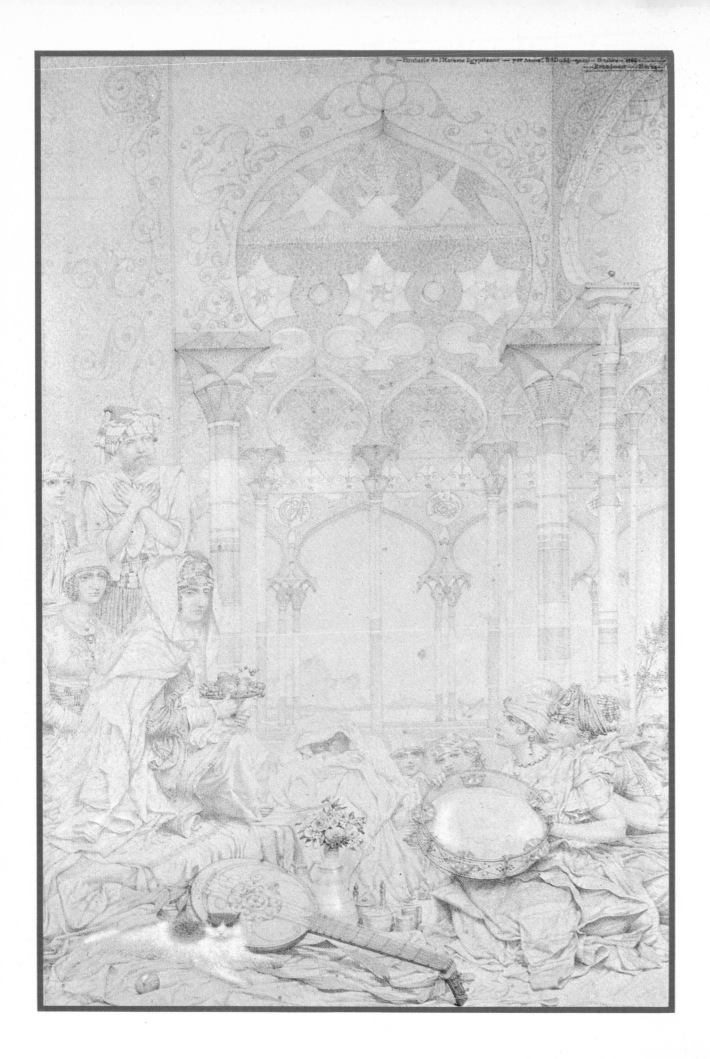

(left) **XIII** *Fantasie de l'Hareme Egyptienne* 1865, watercolour

XIV *Port Stragglin* 1861, watercolour

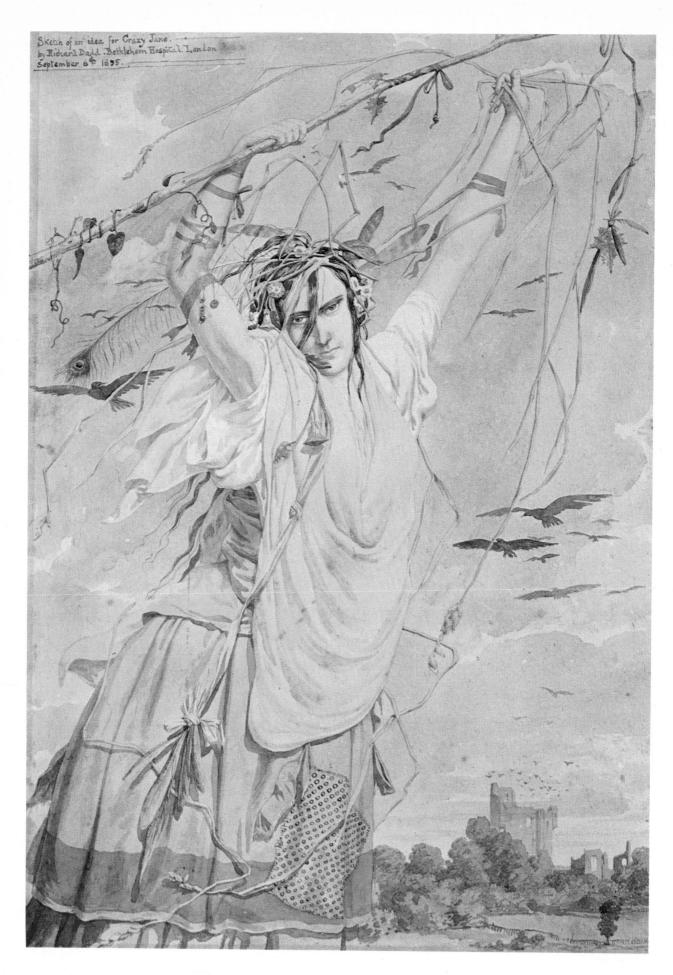

Sketch of an idea for Crazy Jane.
by Richard Dadd. Bethlehem Hospital. London
September 6th 1855.

XV *Sketch of an Idea for Crazy Jane* 1855, watercolour

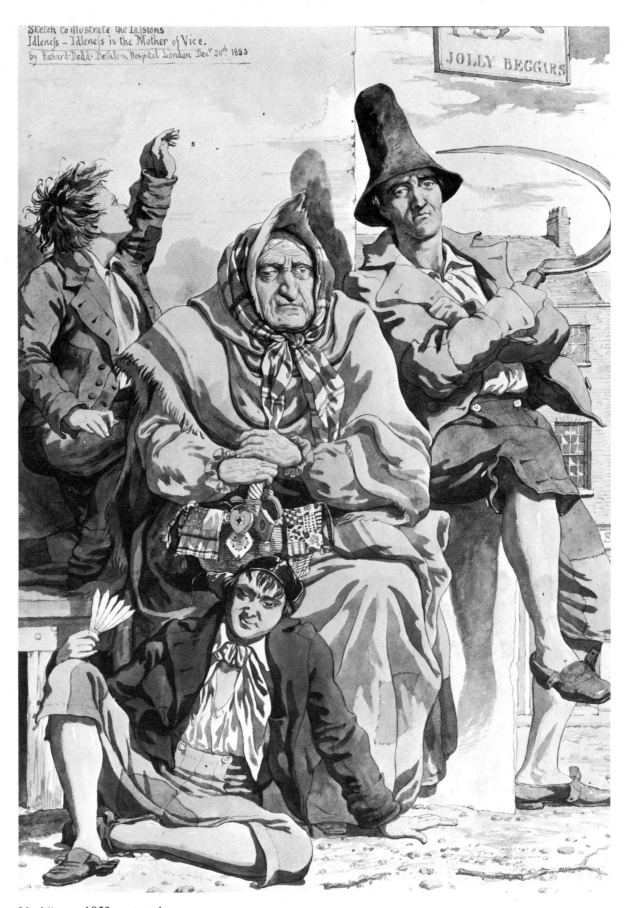

90. *Idleness* 1853, watercolour

91. *Insignificance or Self-Contempt* 1854, watercolour

92. *Self-conceit or Vanity* 1854, watercolour

93. *Deceit or Duplicity* 1854, watercolour

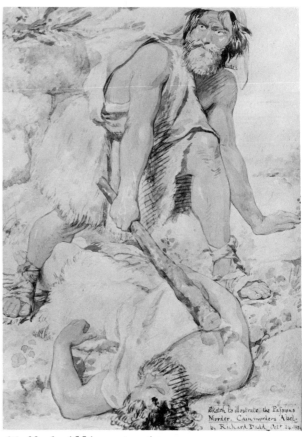

94. *Murder* 1854, watercolour

95. *Grief or Sorrow* 1854, watercolour

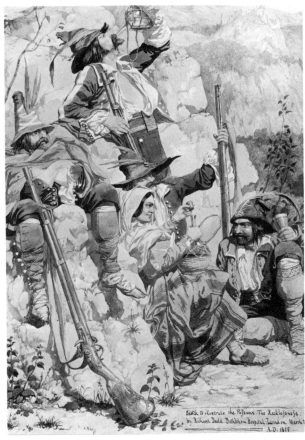

96. *Recklessness* 1855, watercolour

97. *Suspense or Expectation* 1855, watercolour

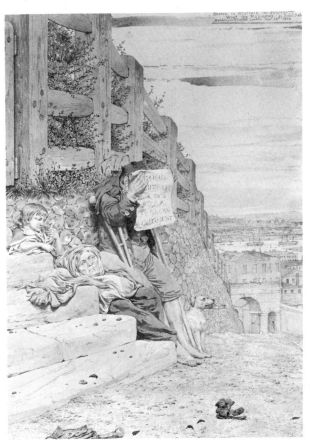

98. *Want the Malingerer* 1856, watercolour

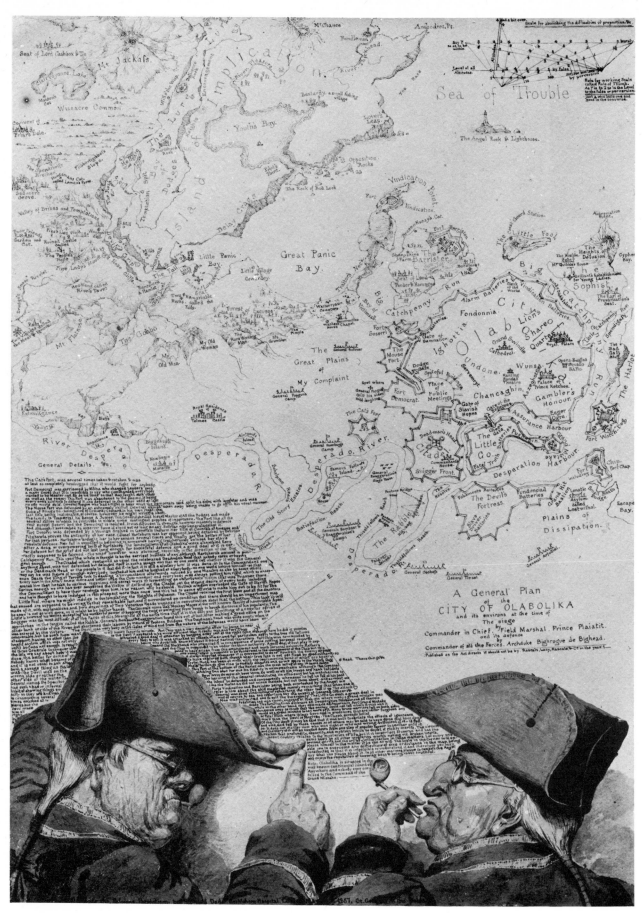

99. *Patriotism* 1857, pen and ink and watercolour

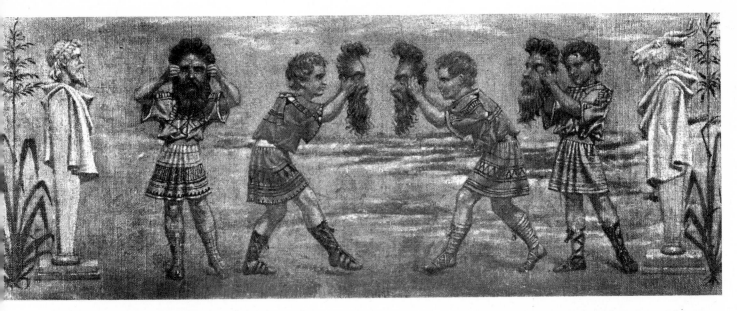

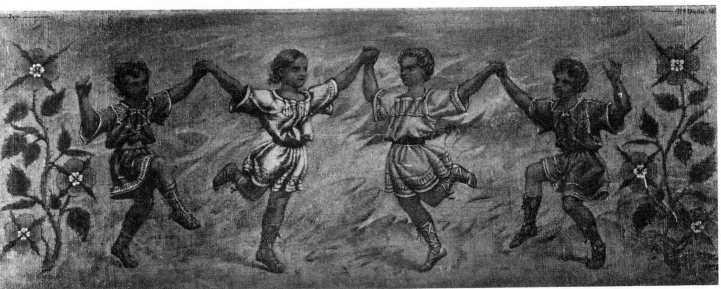

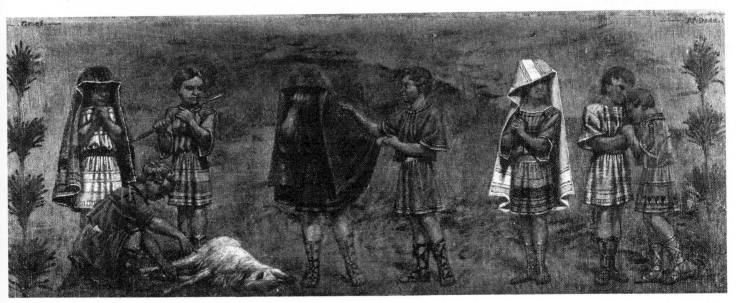

100. *Folly, Joy and Grief, panels from the stage at Broadmoor* 1874, oil on hessian

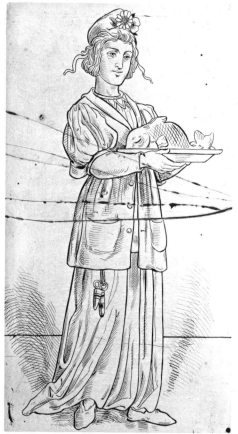

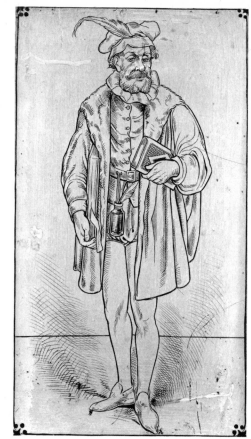

101. *Housekeeper* after 1864, glass panel

102. *Scribe* after 1864, glasspanel

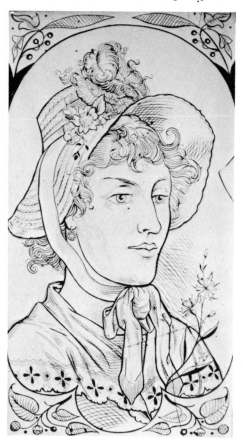

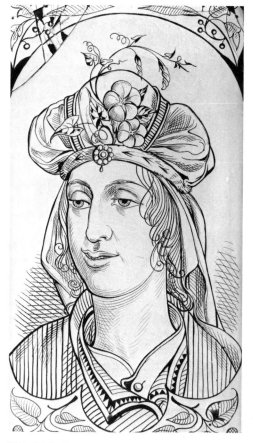

103. *Female Head* after 1864, glass panel

104. *Male Head* after 1864, glass panel

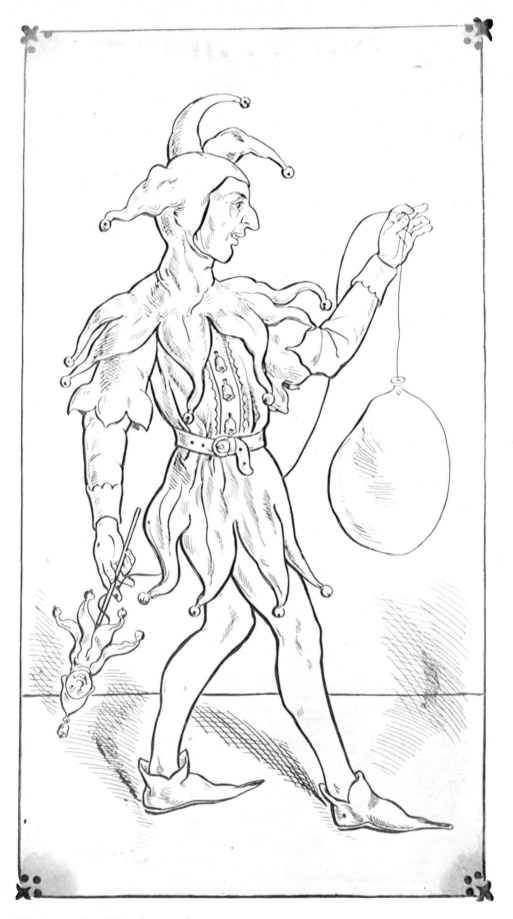

105. *Jester* after 1864, glass panel

NOTES TO THE COLOUR ILLUSTRATIONS

Dimensions are given in inches, height precedes width

I. The Fairy Feller's Master-stroke
1855-64 Oil on canvas 21¼ x 15½
(The Tate Gallery)

Painted in Bethlem for G. H. Haydon, steward of Bethlem Hospital. In a long poem written after he had been transferred to Broadmoor, Dadd identified all the characters assembled to watch the fairy woodman crack a hazel nut. The various groups in the lower circle, moving counter-clockwise from the fairy feller, are: ostler, monk ploughman and 'Waggoner Will'; two men-about-town: a clodhopper with satyr's head (seated), a politician, 'some fairy dandy' and his nymph, two elves, a pedagogue (crouching), and the Arch Magician behind; two ladies' maids, Lubin and his 'Chloe or Phyllis'; two dwarf conjurers. Along the brim of the magician's hat are Queen Mab and her cortège on the left, Spanish dancers on the right, with Oberon and Titania and 'a harridan' higher up. At the top left are a 'tatterdemalion and a junketer' and 'a dragonfly trumpeter'; to the right are soldier, sailor, tinker, tailor, ploughboy, apothecary, thief. Dadd's final comment, however, is that you can believe all this or not as you choose, since it explains nothing. The picture is unfinished, some of the nuts, the woodman's axe, and a piece of grass, being only sketched in.

II. Come unto these Yellow Sands
1842 Oil on canvas 21¾ x 30½
(From a Private Collection, photograph courtesy of The Tate Gallery)

Exhibited Royal Academy, 1842. The picture was one of the attractions of the Academy exhibition, and a contemporary critic thought that it came nearer to the essence of poetry than anything he had ever seen. It was painted shortly before Dadd left England, on the journey from which he returned insane. Examining the details in the light of hindsight it is possible to find prophetic hints of a feverish imagination, but there is nothing of this in the controlled purity of the design.

III. The Diadonus Advancing Backwards and Giving a Heavy Lurch to Windward
1861 Oil on panel 8 x 21
(Private Collection)

Painted in Bethlem. Dadd's slightly jokey title inscribed on the back, which includes the information 'wind due NORTH', belies the fact that this is one of his most powerful and memorable sea pieces. Its misty greens and pinks haunt the imagination as the sea itself haunted Dadd's, the tossing boats symbolizing a life now lost to him except in dreams. Craggy rocks and sheer cliff faces are a recurring theme throughout his later work, for example *Port Stragglin* and *Composition,* and are present in the background of many other works.

IV. Caravan Halted by the Seashore
1843 Oil on canvas 35½ x 59½
(Miss V. R. Levine)

Exhibited Liverpool Academy, 1843. The scene shows a group of water carriers at a spring on the shore of Fortuna, near Mount Carmel, and was painted between Dadd's return from his Middle Eastern journey and the killing of his father. The gentle colours and atmosphere of limpid calm give no hint that his mental disorder was building up to its most frenzied period while he was at work on this picture.

V. The Flight out of Egypt
1849-50 Oil on canvas 39½ x 49¾
(The Tate Gallery)

Painted in Bethlem. Dadd did not give this picture a title and its subject is completely obscure. The group in the bottom left-hand corner clearly refers in some way to the Holy Family while much of the rest is an amalgam of episodes from the Middle East sketchbook, memories of the journey, and imagination. The richly dressed soldiers, with their 'Oath of the Horatii' gestures and the extraordinary ridged veins of their forearms, introduce an almost surrealist element which is equalled by many of the strange juxtapositions in the elaborately contrived design. The exaggeratedly hostile or hunted expressions on some of the faces must reflect something of Dadd's own state of mind at this time.

VI. Evening
c. 1841 Oil on panel 9 x 7½
(Patricia Allderidge)

The specific subject of this picture is not known, but the figure could easily have been one of the fairy dancers in *Puck,* which it closely resembles in lighting and colour. The basic characteristics of all the fairy paintings are here, and in this simple study it is possible to see in almost diagramatic form the elements of design by which Dadd achieves his effects in the more elaborate works. Though there is open landscape in the distance, the immediate background isolates the figure, and dramatic spotlighting further defines her position as if at the front of a stage. She is held tightly in a self-contained world, emphasized by the reflection of her shape in the overhanging grasses and the relationship of every detail in the foliage to some line of her body. Much of the magic of Dadd's fairy painting comes from his ability to create, as he does here, a figure which appears to have materialised *in situ* and to have no means of getting away that will not leave a sudden empty space and a slight turbulence in the air.

VII. Contradiction. Oberon and Titania
1854-58 Oil on canvas 24 x 29¾
(Private Collection)

Painted in Bethlem for Dr. W. Charles Hood, physician superintendent of Bethlem Hospital. Some of the hoardes of tiny figures swarming through the foliage are nearly invisible to the naked eye. At the bottom they are mainly soldiers with shields and winged fairies in voluminous robes; at the top, among the weird but exquisite still life and architectural contrivances, are a group of revellers with the body of a deer and various other individuals, all highly fantastic. The details are painted with almost incredible precision, epitomized by the perfectly formed features of the smallest

fairies and the dewdrops lying thickly on every surface and hanging from every leaf. Although this is in most ways utterly different from the early fairy paintings a number of the features are developed from *Titania Sleeping*, notably some of the plants, and the overall structure of the composition. A striking contrast is between the dainty moon-born Titania of the first work and the hulking Amazon who here tramples elves underfoot. The later version, surprisingly, takes a far more light-hearted approach to fairyland.

VIII. Puck
1841 Oil on canvas 23 $\frac{1}{4}$ x 23 $\frac{1}{4}$
(From a Private Collection, photograph courtesy of The Tate Gallery)
Exhibited Suffolk Street Galleries, 1841; Manchester Art Treasures Exhibition, 1857. Together with its companion picture *Titania Sleeping*, this was considered one of the most successful works which Dadd painted while still a student at the Academy, and both won high praise. The concept of the baby Puck sitting on a toadstool is based on Reynolds's version.

IX. Bacchanalian Scene
1862 Oil on wood 12 x 9 $\frac{1}{2}$
(Private Collection)
Painted in Bethlem. Though formerly known as *Circe* the subject seems to be more closely connected with Bacchic revelling, and Dadd must have had Rubens's *Triumph of Silenus* in mind for the head of the satyr. Stylistically, the painting is most closely related to *The Fairy Feller* and *Oberon and Titania*. On the back and repeated round the bowl of the cup is a slightly erratic Latin verse in which Dadd declares his belief in man's subservience to his own individual fate.

X. Titania Sleeping
1841 Oil on canvas 25 $\frac{1}{2}$ x 30 $\frac{1}{2}$
(Miss V. R. Levine)
Exhibited Royal Academy, 1841; Manchester Art Treasures Exhibition, 1857. The deliberately theatrical setting is emphasized by a proscenium arch, whose central monster figure owes something to Blake and Fuseli. The main group is composed as a Nativity, the pose of the left-hand figure being taken directly from the shepherd in Giorgione's *Adoration of the Shepherds* (the 'Allendale Nativity'), while other features, particularly of design, are influenced by Daniel Maclise. But already in these early pictures Dadd was able to assimilate his consciously borrowed ideas into an entirely personal and original creation.

XI. Mother and Child
1860 Oil on canvas 19 $\frac{1}{2}$ x 13
(The Fine Art Society)
Painted in Bethlem. Since Dadd's creed incorporated a belief that he was descended from the Egyptian god Osiris, it is not surprising to find a rather ambivalent approach to an ostensibly 'religious' subject. Obviously it is intended to be read as a Madonna and Child, but the halo can also be seen as arising accidentally from the sun's nimbus; certainly Dadd delighted elsewhere in superimposing images to confuse the interpretation. The child's slightly baleful expression is

also rather unorthodox. The picture has strong Nazarene overtones. The soft draping of the cloth and the pale purity of the colouring are outstanding even by Dadd's standards and with the mesmeric clarity of the plants and bird, and the phantom ship on a ruffled sea, Dadd has created one of his most memorable images.

XII. The Fairies' Rendezvous
c. 1841 Watercolour 9 $\frac{5}{8}$ x 11 $\frac{3}{8}$
(Walker Art Gallery)
The drawing was given by Robert Dadd to his friend William Clements, and is inscribed on the back 'Sketch for a picture which has been painted by my son Richard . . . The Fairys Rendezvous'. The painting for which it is a sketch has not yet been found.

XIII. Fantasie de l'Harème Egyptienne
1865 Watercolour 10 $\frac{1}{8}$ x 7
(Ashmolean Museum)
Painted in Broadmoor. Dadd continued to use material from his Middle Eastern journey all his life, but in the later works there is little attempt at a realistic interpretation. This watercolour has the true quality of a dream, or even an hallucination, in the tonality and colouring and in the combination of pure fantasy with minutely precise detail.

XIV. Port Stragglin
1861 Watercolour 7 $\frac{1}{2}$ x 5 $\frac{1}{2}$
(British Museum)
Painted in Bethlem. Dadd's full title for his imaginative port scene, distilled from many different memories, is 'General View of Part of Port Stragglin. The Rock & Castle of Seclusion and the Blinker Lighthouse in the Distance not sketched from Nature'. Also on the back he has written several inconsequential remarks such as 'Not a bit like it. What a while you are! I don't like it. No.' It is one of his most intensely visionary scenes, and a fine example of the extremely delicate technique using the tip of a very fine brush which Dadd developed.

XV. Sketch of an Idea for Crazy Jane
1855 Watercolour 14 $\frac{1}{8}$ x 10
(Bethlem Royal Hospital)
Painted in Bethlem. This is one of the most lyrical of all the watercolours, with its subtle harmonies of line and colour. The subject is taken from *Poor Crazy Jane* , a popular nineteenth-century ballad about a young woman driven out of her wits by her false lover's desertion. The song was probably remembered by Dadd from his youth, and in the background of the drawing are echoes of landscape near his home at Chatham. 'Jane' is obviously modelled from a man, probably one of his fellow patients.

NOTES TO THE BLACK AND WHITE ILLUSTRATIONS

Dimensions are given in inches, height precedes width

1. Contemporary engraving of Suffolk Street, Pall Mall East, London. Dadd and his family moved to 15 Suffolk Street (located near the Suffolk Street Gallery) from Chatham in 1834

2. **Portrait of Robert Dadd jun.**
c. 1840 Oil on board, oval 15 x 13⅜
(Private Collection, photograph courtesy of the Tate Gallery)
A label on the back identifies the sitter and the approximate date. Robert, the eldest brother, was born 13 July 1813 and died in 1876. After practising as a chemist in Whitechapel for many years, he reluctantly went into another occupation, possibly his father-in-law's ship-building business. He, and later his descendents, maintained contact with the scattered members of the family, and much information comes from the letters which he exchanged with his two half-brothers in America.

3. **Portrait of John Alfred Dadd**
c. 1839 Watercolour oval 5 x 3⅝
(Private Collection, photograph courtesy of The Tate Gallery)
A note on the back reads 'John Alfred Dadd 1829-95 at age 10. Painted by Rd. Dadd his half-brother circa 1837', but if the age is correct the date must be later. John was born 24 May 1829, the second of two sons by Robert Dadd's second marriage. He was apprenticed to his brother Robert to learn pharmacy and emigrated to America in 1850. Settling in Milwaukee, he established a drug store and eventually became one of Wisconsin's leading and most influential pharmacists. His only child Robert succeeded him in the business but died without issue.

4. **Portrait of George William Dadd**
c. 1840 Watercolour 4¾ x 3
(Private Collection, photograph courtesy of The National Portrait Gallery)
A note on the back reads 'Portrait of G. Dadd by Rd. Dadd, aged 17'. George was born 13 December 1822, the youngest of Dadd's full brothers. He was a skilled carpenter in the dockyard at Chatham, but began to show signs of mental disorder when he was twenty and became completely insane at the same time as his brother in 1843. He was admitted to Bethlem Hospital where he remained until his death in 1868, but the brothers are unlikely to have met as there was no contact between the criminal department and the ordinary patients.

5. Portrait of Dadd's sister Maria Elizabeth, by her husband John Phillip. Phillip, a member of The Clique, was among Dadd's friends at the Royal Academy.

6. **Songe de la Fantasie**
1864 Watercolour on ivory board 15 1/16 x 12⅜
(The Fitzwilliam Museum)
Painted in Broadmoor. This watercolour replica of *The Fairy Feller's Master-stroke* was made after Dadd had been moved to Broadmoor, presumably leaving the original behind with G. H. Haydon for whom it had been painted. It need not have been drawn entirely from memory as he could have had sketches with him. The chief differences in design lie in the calligraphic swirls across the surface of the picture, which here are given greater prominence and complexity; there are also one or two deliberate and inexplicable, if minor, alterations such as a change in the shape of Oberon's crown. Perhaps most striking is the complete change in tonality and, perhaps partly as a result of this, Dadd's failure to recapture the intensity and individuality of the original figures. In this version they have lost concentration and that rapt self-absorbtion which gave them their unique character—they have become shadows of themselves. But then, the picture is called *Songe de la Fantasie* and not *The Fairy Feller's Master-stroke,* and its shadowy dreamlike texture is in keeping with the new title, whatever Dadd's exact intention may have been.

7. Engraving of Cobham Hall, Kent. Dadd spent much time sketching here as a boy, later returning to the area for the murder of his father.

8. Photograph, taken in the 1920s, of the entrance to Bethlem Hospital.

9. Contemporary photograph of Bethlem Hospital where Dadd was confined.

10. Contemporary engraving of an ordinary ward at Bethlem, similar to the one to which Dadd was moved in 1857.

11. Contemporary engraving of a female airing-court at Broadmoor Hospital.

12. Contemporary engraving of a day room for male patients, Broadmoor Hospital.

13. Contemporary engraving of a male and a female dormitory, Broadmoor Hospital.

14. **Portrait of Dr. William Orange**
1875 Oil on canvas 26½ x 22
(Broadmoor Hospital, photograph courtesy of The Paul Mellon Centre)
Painted in Broadmoor. The background has been retouched. This is one of only three known portraits which Dadd painted while in Bethlem or Broadmoor. Both the large scale and naturalism are unexpected at this late period of his life but the technique and finish are in keeping with his more usual miniature work. The naturalism suggests that many of Dadd's stylistic developments in figure drawing may have been conditioned by his lack of models. Dr. Orange was attached to Broadmoor from its establishment and succeeded as superintendent in 1870. Dadd also painted a mural for him in the superintendent's official residence.

15 Early photograph of a terrace at Broadmoor Hospital, from *The Story of Crime,* H. L. Adam. C. 1908

16. Water Nymphs
c. 1841 Etching $4\frac{5}{16}$ x $3\frac{13}{16}$
(Christopher Mendez Esq.)
Unsigned, this etching was inscribed in the margin by Robert Dadd 'Designed and etched by my son Richard. I May 1843. To Mr. Clements'. William Clements was a close friend of the family. The date must refer to when the etching was given to him, since Dadd did not return from the Middle East until the end of May. From its technical quality it seems likely to have been one of his early attempts with the medium, and presumably dates from around the time of the earliest fairy paintings.

17. A Fishing Fleet in a Storm
1877 Watercolour $5\frac{5}{8}$ x $3\frac{7}{8}$
(Patricia Allderidge)
Painted in Broadmoor. In *Port Stragglin* Dadd seemed to have reached the limits of his microscopic point-of-the-brush technique, but this lively little shipping scene, though less intricately detailed, offers further refinements. At first glance it resembles *The Pilot Boat* in the way the sea is painted, but although the tone is even paler, there is colour and movement here which would have been alien to the mood of the earlier work. More naturalistic than most of the earlier shipping pictures, this tiny microcosm represents a concentration of all Dadd's resources, a final distillation of the theme which had held him in thrall through thirty-three years of deprivation.

18. Still Life with Bottles and Corkscrew
c. 1834 Oil on board $10\frac{1}{4}$ x 8
(From a Private Collection)
The date is very indistinct, but a possible reading is 1834, when Dadd would have been seventeen. In all events it is an early work and seems to have been influenced by Dutch models, the brown and dark colouring being particularly suggestive in this respect.

19. The Bridge
1837 Oil on board $8\frac{1}{4}$ x $11\frac{1}{4}$
(Whereabouts unknown)

20. Landscape
1837 Oil on board $6\frac{1}{2}$ x $20\frac{1}{4}$
(York City Art Gallery)
This and its companion work *The Bridge* could be different views of the same stretch of stream. They date from the first year of Dadd's admission to the Academy Schools, though only this one is known at firsthand. As the students were taught painting only after a long apprenticeship in drawing, these landscapes must represent the style in which Dadd was already working, one which seems to derive its main influence from Constable. Except for a few early portraits, the brush-work is freer here than anywhere else in his work, but the small scale is in character with his life-long preference.

21. A Country Churchyard
c. 1842 Etching $5\frac{1}{16}$ x 6
(Christopher Mendez Esq.)
Unsigned, this etching is inscribed in the margin by Robert

Dadd with a quotation from Gray's *Elegy in a Country Churchyard* . It was given to William Clements. Early in 1842 Dadd became a founder member of the Painters' Etching Society and the design was probably made in connection with the Society's unfulfilled project to produce an illustrated edition of the 'Elegy'.

22. Figures in a Landscape
Early 1830s Watercolour $5\frac{1}{4}$ x $4\frac{3}{4}$
(Private Collection)
This picture, which has been preserved in the family of one of Dadd's brothers, is probably one of his earliest sketches. A writer in *The Art Union* for October 1843, someone who had known Dadd almost from childhood wrote: 'There is little doubt that he imbibed his early love of Art from his boyish acquaintance with the rich and varied scenery of his native country . . . in many of his early sketches we can trace outlines of the dells and noble trees in his favourite part of Cobham, the very place where his young genius received its inspiration.'

23. The Olive Grove at Athens
1842 Pencil $5\frac{1}{2}$ x $8\frac{1}{8}$
(Victoria and Albert Museum, photograph courtesy of The Paul Mellon Centre)
A page from the sketchbook.

24. View in the Island of Rhodes
1845-56 Watercolour $9\frac{5}{8}$ x $14\frac{5}{8}$
(Victoria and Albert Museum, photograph courtesy of The Paul Mellon Centre).
Painted in Bethlem. This drawing was among the possessions of Sir Charles Hood sold after his death in 1870. All the drawings were given the covering dates 1845-56 in the sale catalogue. It is painted in a combination of wash, very fine stippling and drawing with a fine brush, and could have been one of the watercolours on which Dadd was working in 1845, described as 'absolutely wonderful in delicate finish.' It is inscribed on the back 'Vieuw [sic] in the Island of Rhodes, near the site of a castle of the Knights of St. John, a part of which still remains in ruins.' Dadd and Sir Thomas Phillips spent several days on Rhodes waiting for the steamer in October 1842, and he probably had more time for sketching then than at any other point in the journey.

25. View on the Gulf of Corinth
1842 Pencil $5\frac{1}{2}$ x $8\frac{1}{8}$
(Victoria and Albert Museum, photograph courtesy of The Paul Mellon Centre)
A page from the sketchbook, with two details of Greek fountains.

26. Composition
1857 Watercolour $6\frac{7}{8}$ x $9\frac{7}{8}$
(Alister Mathews)
Painted in Bethlem. Dadd's own title is simply *Composition. Sketch.* , and it might have been put together from sketchbook material as well as from memory. The castle was probably derived from memories of Rochester castle, and the rest

of the scenery may be from around the Chatham area.

27. A Dream of Fancy
1859 Watercolour $3\frac{7}{8}$ x $5\frac{3}{4}$
(From a Private Collection, photograph courtesy of Sotheby's)
Painted in Bethlem. Dadd used the title again, in French, for a completely different subject and it evidently expresses something of his intention in these misty visionary works of imagination. This exquisitely delicate little landscape, stippled in near monochrome shades of dull green, with touches of white picking out the mountain peaks, may contain elements from the scenery he had sketched fifteen years earlier in southern Turkey, around Xanthus and Tloes. It was given by G. H. Haydon, steward of Bethlem Hospital, to Myles Burket Foster; and in view of Birket Foster's own style, it is not difficult to see why he should have been attracted to this particular work.

28. Pope's House, Binfield, known as The Gardener
Before 1864 Oil on board 8 x 12
(Private Collection, photograph courtesy of Sotheby's)
Painted in Bethlem. A label on the back formerly identified this as Pope's House at Twickenham; the painting was actually copied, with some additions, from an engraving of Pope's House at Binfield, published in Thomas Dugdale's *England and Wales Delineated*. It must have been painted before Dadd left the hospital, as it was given by the steward of Bethlem to a Mr. Shields, whose family firm had been associated with the hospital for many years. The figure carrying spade and fork, which Dadd introduced together with all the plants in the foreground, closely resembled his father.

29. Composition (Sketch for the Broadmoor Theatre Drop-curtain)
1873 Watercolour $12\frac{1}{16}$ x $16\frac{5}{8}$
(Victoria and Albert Museum)
Painted in Broadmoor. Although inscribed only *Composition*, this watercolour is obviously related to *The Temple of Fame* which Dadd painted for the drop-curtain (now destroyed) of the Broadmoor stage, once described as 'an elegant Greek edifice standing on a single peak, which soars high into the clouds of a wild and stormy sky. Crowds press onwards and upwards by a series of winding stairs and platforms, but upon the crag-summit there is foothold for but one at a time; in the foreground is a wide terrace . . . it is crowded with figures - some eager, some apathetic, some pointing with feelings of envy or contempt to those who are already on the rise, while new arrivals are making for the shore in triremes and galleys under oar and sail . . .' The brilliant yellow gold of the galley and warm golden tones of the grass and trees, are in contrast to the cool blues and blue greens of most of the landscapes and shipping scenes.

30. Camels and The Coast of Cyprus
1842 Pencil $5\frac{1}{2}$ x $8\frac{1}{8}$
(Victoria and Albert Museum, photograph courtesy of The Paul Mellon Centre)

31-33. Figure Studies in Turkey and Syria
1842 Pencil $5\frac{1}{2}$x $8\frac{1}{8}$
(Victoria and Albert Museum, photograph courtesy of The Paul Mellon Centre)
These studies are taken from three separate pages of the sketchbook.

34. Caravanserai at Mylasa in Asia Minor
1845 Oil on panel $8\frac{7}{8}$ x 12
(Mr. and Mrs. Paul Mellon, photograph courtesy of Thos. Agnew and Sons)
Painted in Bethlem. This is the earliest known work dated from Bethlem, and it is interesting to see that Dadd inscribed his work with 'Bethlem Hospital' from the first year of his confinement. Known only from a photograph, it is one of the most naturalistic of all the pictures painted after his illness, certainly far more so than *The Flight out of Egypt* of four years later. The sketch from which it was taken must have been made in the first week in October, 1842, when Dadd and Sir Thomas Phillips passed through Mylasa; there is another view of the caravanserai in the sketchbook at the Victoria and Albert Museum. The painting seems to have emerged from the hospital by 1847, since there is a label on the back bearing the date and authenticating it as having been painted by Dadd, 'a prisoner in Bethlem Hospital'.

35. Arab Ambush
1864 Watercolour $14\frac{3}{4}$ x $11\frac{3}{4}$
(Private Collection, photograph courtesy of The Tate Gallery).
Painted in Bethlem. This must have been one of the last pictures Dadd painted before being transferred to Broadmoor. In the previous year he had painted several other untitled Eastern scenes, apparently working from some of the figure studies in his sketchbook as well as from the landscapes. This is more fanciful than those which preceded it and comes somewhere between them and the Egyptian 'fantasies' painted at Broadmoor.

36. At Bethlehem near the Greek Convent of the Nativity of Christ
c. 1845 Watercolour $7\frac{1}{2}$ x $5\frac{5}{8}$
(From a Private Collection, photograph courtesy of Sotheby's)
Possibly painted in Bethlem. This delicate little watercolour loses much of its character without the sunlit golden browns and pale ochre of its predominant colours or without the very fine drawing and stippling with the point of the brush which can be seen only in the original. There is no indication when it was painted, but it could be one of the drawings on which Dadd was working in 1845. The original sketch must have been made on 22 November 1842, when Dadd visited Bethlehem, though this scene is too carefully designed with its triangular grouping of the figures and diagonal lines echoing each other throughout the details to have been taken direct from life.

37. A Turk
1863 Watercolour $2\frac{1}{2}$ x $2\frac{1}{2}$
(The Tate Gallery)
Painted in Bethlem. The texture of this tiny drawing is too

fragile to be reproduced adequately in black and white. Its colouring is soft and subtle, palest ochre with touches of coral in the background, shades of blue grey for the old man's dress and turban, with a single spot of bright red where the top of a fez shows through the swathed cloth. It resembles several studies in the surviving sketchbook, and must have been taken directly from the book which Dadd had with him.

38. Fantasie Egyptienne
1865 Watercolour 10 x 7
(Private Collection)
Painted in Broadmoor. A companion picture to *Fantasie de l'Harème Egyptienne* in colouring, size and date, this work has a similiarly frozen, dreamlike atmosphere, though the details of architecture and glimpse of the harbour in the background are realistic and could have been taken directly from sketches. The fantasy lies in the lovely harmonies of palest blues and pinks, and in the misty quality of the drawing that is nevertheless precise and detailed. Dadd's habit of writing in French had been noted earlier when he was first admitted to Bethlem. Here he signs himself 'Monsr. R. Dadd'.

39. A Seated Arab
1880 Watercolour $10\frac{3}{4}$ x $6\frac{3}{4}$
(Dr. Raymond Levy)
Painted in Broadmoor. This watercolour, painted within six years of his death, shows Dadd still preoccupied with one of his never failing themes - though his Middle Eastern journey was nearly forty years past. In the simple, almost archetypal figure, he expresses something of the resignation with which he was able to accept his own life towards its end.

40. The Closet Scene from Hamlet
1840 Oil on canvas $40\frac{1}{4}$ x $34\frac{1}{2}$
(Mr. and Mrs. Paul Mellon)
Exhibited, British Institution, 1840 (205); Liverpool Academy, 1840 (266). The painting shows Charles and Ellen Kean in the roles of Hamlet and Gertrude, and was catalogued at both exhibitions with the quotation beginning: 'Ghost. Do not forget: this visitation/ is but to whet thy almost blunted purpose . . .' Known only from a photograph, it does not show any outstanding merits within its genre; but for Dadd it is an unusually large work and is interesting on that account alone, to see how he handled a large and comparatively empty canvas. Elsewhere his response was to use more small figures rather than to design on a larger scale. Unfortunately the ghost has now been eliminated, so we cannot see Dadd's idea of a haunting presence at this time, three years before his delusions on the subject are known to have begun.

41. Newhaven Fisherfolk, known as The Fish Market by the Sea
c. 1849 Oil on canvas $39\frac{1}{2}$ x $49\frac{1}{2}$
(Mr. and Mrs. Paul Mellon)
Probably painted in Bethlem. This work is known only from a photograph. The subject seems to have been taken from D. O. Hill's calotypes of *Newhaven Fishwives,* though no specific single source has been discovered amongst them.

The painting is also related to his *Fishwives* dated 1849, which shows a similar (and unusual for Dadd) roughness in the texture of the paint.

42. Sketch of Jesus Christ Walking on the Sea
1852 Watercolour $10\frac{1}{4}$ x $14\frac{1}{8}$
(Victoria and Albert Museum)
Painted in Bethlem. Whatever its original appearance, fading has given this watercolour a most delicate and memorable tonality. Sky, sea and ship are now a near monochrome greenish grey, the preoccupied isolation of the figures emphasised by the stronger blue and soft mushroom pink of their garments. Dadd's unique treatment of the sea suggests simultaneously a textured surface strong enough to support the feet of Christ, and the heaving turmoil into which Peter is sinking. It is one of the endless variations which he worked on the theme of moving water. A ship very similar to this, even to the hooded figure in the stern, is found in the sketchbook.

43. Fishwives
1849 Oil on canvas $23\frac{3}{4}$ x $19\frac{3}{8}$
(Mr. and Mrs. Allen Staley)
Painted in Bethlem. An almost identical scene appears on a pot lid of the type known as Prattware, produced in the series of 'Pegwell Bay' subjects which decorated fishpaste pots in the 1850s. It is not known whether there was a common source for both versions or whether Dadd took his subject from the lid, though the possibility that this painting was somehow known to the designer of the lid cannot be ruled out. Dadd's identification of a Scottish location through the two figures in Scottish dress (who are not in the pot lid version) helps to relate it to *Newhaven Fisherfolk* of around the same date.

44. The Ballad Monger. A Reminiscence
1853 Watercolour $10\frac{1}{16}$ x $14\frac{1}{16}$
(The British Museum, photograph courtesy of the Paul Mellon Centre)
Painted in Bethlem. Dadd here recalls the itinerant ballad-sellers of his childhood, whose broadside song sheets were hung up like washing on a line for inspection. Many or all of the titles shown here are authentic. Elsewhere he illustrated particular ballad subjects, such as *Crazy Jane* and *Joe the Marine.* This is one of the finest examples of Dadd's watercolour work in his style which uses even, controlled washes and broad shadows, indicating texture and fabric with great economy. It also contains some of his most satisfying drawing and colouring, particularly in the group on the left-hand side.

45. Sketch of Polyphemus Discovered Asleep by the Shepherds of Sicily
1852 Watercolour 10 x 14
(The Forbes Magazine Collection, photograph courtesy of Sotheby's)
Painted in Bethlem. The subject of Polyphemus offered unlimited scope for the depiction of ferocious horrors, but Dadd chose to make this a particularly peaceful scene. The previous year he had painted an exceedingly violent *Dymphna Martyr,* so there is no chronological sequence from calm to more aggressive subjects. Perhaps because of the

dearth of models, or just for his own amusement, he often re-uses small details or gestures, sometimes a pose or even a complete figure, for quite different purposes. Here Polyphemus's right hand encircles a knob of rock with the same gesture as the dying servant clutching the air in *Richard II*; the same attitude can be seen in *The Child's Problem* and *Splendour and Wealth*. The shepherd leaning with arms outspread can be found again in *The Flight of Medea with Jason* of 1855 (not reproduced) and in *Arab Ambush*, while the hunting horn reappears, along with some of the trees, in, *Robin Hood*.

46. Sketch of the Death of Richard II in Pomfret Castle
1852 Watercolour 14$\frac{3}{16}$ x 10$\frac{3}{8}$
(Private Collection)
Painted in Bethlem. Clearly related to the later 'Passions' drawings in both style and subject matter, this watercolour is one of the most actively violent of all Dadd's works. The colouring, brighter than most of the watercolours and including scarlet, blue and yellow, links it with *The Flight out of Egypt,* as does the obsessionally placed central figure. Nowhere can Dadd's skill in design be seen more clearly than by comparing this drawing with *Melancholy*, where the atmosphere is created largely through the lines of the figures.

47. Sketch of Robin Hood
1852 Watercolour 13$\frac{5}{8}$ x 9$\frac{3}{4}$
(Mr. and Mrs. Paul Mellon)
Painted in Bethlem. The picture is known only from a photograph, but the foreground, and particularly the stream, is characteristic of Dadd's best work.

48. The Packet Delayed
1854 Watercolour 14$\frac{1}{2}$ x 10
(Trustees of Sir Colin and Lady Anderson, photograph courtesy of Thos. Agnew and Sons)
Painted in Bethlem. Apparently a companion picture to *Juvenile Members of the Yacht Club*, this takes a light-hearted look at what should have been a conventional shipping subject, and is doubtless intended to recall Turner's painting of the same title. In such scenes Dadd paints his reminiscences of childhood with a total lack of the sentimentality which his contemporaries could rarely avoid when depicting children. The small boys who are, or who knew, his childhood self also appear in *The Ballad Monger, Polly of Portsmouth* and elsewhere. The close-up study of choppy water combines the treatments used in *Jesus Christ Walking on the Sea* and *Venice.*

49. Sketch of Juvenile Members of the Yacht Club
1853 Watercolour 14 x 10$\frac{1}{8}$
(Mr. and Mrs. Paul Mellon, photograph courtesy of Thos. Agnew and Sons.
Painted in Bethlem. The background is extremely pale, or possibly faded, showing the hill behind Chatham and part of the 'lines', the fortifications which protected the dockyard. There are some ambiguities in the perspective, scale and the spatial relationships in general. The wearing of an Elizabethan ruff with a reefer jacket is inexplicable, except in terms of Dadd's fondness for introducing ruffs and ruff-like frills in unexpected places. The *Passions* drawing, *Suspense,* has another remarkable example, as does *The Child's Problem.*

50. Sketch of a Hermit
1853 Watercolour 14$\frac{1}{8}$ x 10$\frac{1}{8}$
(Cecil Higgins Art Gallery)
Painted in Bethlem. Though not so interesting in content as some of the others, this drawing is very pleasing in design and colouring. As in *Melancholy*, the figure melts peacefully into his surroundings, his brown robe harmonizing with the pale sandstone. A touch of muted colour is added in the flowers at the foot of the crucifix and the accessories of skull, hour glass, crucifix and book are drawn with a sharp precision offseting the gentler lines of coarse cloth and crumbling rock, a reminder of finite time in an atmosphere of eternity. Dadd's own experience had much in common with that of a hermit, but it is unlikely that by the date of this picture he had achieved very much of the tranquillity shown here.

51. Settling The Disputed Point
1854 Watercolour 14$\frac{3}{8}$ x 10
(Mr. and Mrs. Paul Mellon)
Painted in Bethlem. This is one of Dadd's few excursions into straightforward genre subjects, without the pretext of illustrating anything. Some of the same pictorial ground is covered in *Brutality* which was painted the same year, the group framed in the doorway being the most notable similiarity. There seems to be an unusual lack of confidence in parts of this picture, and particularly an uncertainty about which of his watercolour techniques to use.

52. Polly of Portsmouth and Joe the Marine
1854 Watercolour 9$\frac{1}{2}$ x 13$\frac{1}{3}$
(John Hewett Esq.)
Painted in Bethlem. The subject was taken from the ballad *Poor Joe the Marine*, though Dadd's memory of it seems to have been rather faulty. The girl whom Joe married was Polly of Portsea; but the accumulation of children shown here is not easily reconciled with the song's assertion that 'The bright torch of Hymen was scarce in a blaze, when thundering drums they heard rattle' and Joe went off to his untimely death. The setting is more likely to be Chatham than Portsmouth, with Chatham church seen through a gap in the 'lines'.

53. Lucretia
1854 Watercolour 12 x 10
(The Bethlem Royal Hospital, photograph courtesy of The Paul Mellon Centre)
Painted in Bethlem. Like a number of the *Passions* sketches this was painted on brown paper. It dates from within a month of *Columbine* and seems to have been inspired by the same model. It may also contain a near pastiche reference to Guido Reni's *Lucretia* in the Dulwich Gallery.

54. Mercy. David spareth Saul's Life
1854 Oil on canvas 27 x 22
(The Fine Art Society)
Painted in Bethlem. The title, inscribed on the back with

a reference to Samuel I, 26, has been covered in relining. This is one of Dadd's few excursions into Biblical subjects, though he did paint a large *Good Samaritan,* now lost, which hung on the staircase at Bethlem. The statuesque simplicity of the main group is in complete contrast with the other major Middle Eastern painting, *Flight out of Egypt,* though the foreground details are painted with the same sharp focus and obviously come from the same source. The colouring of bluish green, dull coral, fawn and yellowy buff is quiet, but the whole scene is brightly moonlit. It is a fine work which achieves grandeur in spite of the small scale, and there are some beautiful subsidiary passages, such as the border of David's robe where it hangs in folds below the outstretched arm.

55. The Child's Problem. A Fancy Sketch
1857 Watercolour 6¾ x 10
(The Tate Gallery)
Painted in Bethlem. The picture was owned by the head attendant of Bethlem Hospital, and remained in his family until presented to the Tate Gallery. It is one of the most baffling of all Dadd's watercolours, though the central subject is exactly what the title suggests - a problem so simple that it could have been composed by a child: the position on the board shows a chess problem, 'white to play and mate in two moves'. The significance of the carefully chosen accessories, such as the anti-slavery pictures on the wall and the weird plant-holder, the child's strange costume and stranger expression, and his relationship with the old man, are all matters for endless speculation. Fortunately, for peace of mind, it is always possible to be distracted by the exquisite drawing of some of the details.

56. The Grotto of Pan
1856 Watercolour 10 x 7
(Private Collection)
Painted in Bethlem. This is known only from a photograph. Related in subject matter to *Bacchanalian Scene,* 1862, stylistically, it can be grouped with the 'Passions' and other watercolours from around the same date.

57. Negation
1860 Oil on canvas 20 x 13½
(Mr. and Mrs. Paul Mellon)
Painted in Bethlem. This painting is known only from a photograph. The date, size and part of the content link it with *Mother and Child* and the child and the seated girl with a jug seem to have been drawn from the same model, whether real, pictorial or imagined. Many of the smaller details are reminiscent of much earlier pictures; the grasses on top of the cliff and the waterdrops on the side of the jug date back to *Puck,* the rocky stream and waterfalls in the foreground to *The Flight out of Egypt.* The title, inscribed on the back, places it among a group which includes *Mercy. David spareth Saul's Life,* and *Contradiction. Oberon and Titania.*

58. The Crooked Path
1866 Watercolour 19½ x 14
(The British Museum)
Painted in Broadmoor. Dadd's increasing obsession with precipitous crags and sheer rock-faces can be seen in several of his works, but generally they appear as part of the background. The theme of this picture is probably related to his *Temple of Fame,* painted for the Broadmoor theatre dropcurtain, in which hoardes of people jostle and fight for a single foothold at the top of a winding path. Against the huge expanse of pale gold rock the figures, grey and white with soft coral and two touches of green, are sharply and forlornly isolated.

59. Wandering Musicians
c. 1878 Oil on canvas 24 x 20
(Trustees of the Vaughan Lee Family Trust)
Painted in Broadmoor. Because of the indeterminate nature of the subject this picture has gone under several different names, though for a watercolour version, dated 1878, Dadd used the title *Italian Rustic Musicians* . The setting is eastern Mediterranean. On the broken entablature in the foreground appear the names of the idyllic poets Theocritus, Moschus, and Bion, giving rise to one of the names by which it has been known, *A Greek Pastoral* , which is perfectly in harmony with the mood. Toward the end of his life Dadd's love of the classics and classical subjects seems to have deepened and in 1877, he is known to have been painting *Atalanta's Race* (now lost). This idyllic scene, pale and lowkeyed as the later watercolours, has a sense of space which Dadd never lost throughout his long years of confinement.

60. Portrait of Augustus Egg [?]
c. 1838-40 Oil on panel 25 x 19
(Private Collection)
John Imray, a member of Dadd's student circle, stated that Dadd painted portraits of his friends 'in character'; another contemporary referred to his portrait of Augustus Egg in a tall brown hat like a Puritan. This painting bears a strong resemblance to later portraits of Egg, who was one of Dadd's close friends at the Academy Schools. The brush-work is reminiscent of that of the early landscapes.

61. Portrait of a Girl in a White Dress
1841 Oil on panel 11½ x 8⅛
(Whereabouts unknown, photograph courtesy of Sotheby's)
The sitter has not yet been identified, but the same face appears later in some of Dadd's Bethlem watercolours, *Columbine* for example, so she must have been well known to him. This slightly mannered portrait, almost in the 'keepsake' tradition, is in contrast with the much livelier watercolour portraits of family and friends which he had been making a year or two earlier.

62. Self Portrait
c. 1840 Oil on panel 21½ x 17
(Private Collection)
It is not easy to reconcile all the supposed self portraits, but this one seems closest to the etching of 1841, though in a rather more romanticised mood.

63. Self Portrait
c. 1840 Watercolour 5 x 3⅛
(Private Collection)
A note on the back reads 'Richd. Dadd at age 23. Self

portrait'. All Dadd's small watercolour portraits from around 1838-40 are painted in wash heightened with white, using a slightly greenish flesh tone that gives the sitters a sallow appearance. The overall colouring is always unobtrusive, tending towards pale blues and beiges, and often very attractive.

64. Self Portrait
1841 Etching 5 1/16 x 4 1/2
(Alister Mathews Esq., photograph courtesy of The National Portrait Gallery)
At around this date Dadd was experimenting with the technique of etching. This self portrait was taken from the watercolour.

65. Portrait of Sir Thomas Phillips in Eastern Costume, Reclining
1842/3 Watercolour 6 1/2 x 10
(Private Collection)

66. Portrait of Sir Thomas Phillips in Eastern Costume, Standing
1842-43 Watercolour 9 1/2 x 6 1/2
(Private Collection)
These two portraits of Sir Thomas Phillips were done in the Middle East, the first probably in Syria, the second probably during their boat trip up the Nile. It was normal then for European travellers to adopt local dress for convenience, though Sir Thomas seemed to show a particularly whole-hearted enthusiasm for the style. In a letter to Frith, Dadd described his own travelling costume, which consisted of a loose blouse, Russian leather boots worn outside the trousers and a fez with two handkerchiefs round it. These portraits, particularly in their strong colouring, are closer to the Middle Eastern work of G. F. Lewis than anything else that Dadd produced.

67. Portrait of his Sister [?]
1832 Watercolour 10 7/8 x 9 7/8
(The British Museum)
Though Dadd was only fifteen when he painted this portrait it already shows considerable maturity. The modelling of the face, which suggests a knowledge of the technique of miniature painting, is particularly fine; so too is the piece of brightly lit wooded landscape stretching away to the right. The colouring is quiet, gold and russet-brown trees and grass setting off the girl's black silk dress and dark red shawl. The sitter has been tentatively identified as his eldest sister Mary Ann, but comparison with a recently discovered portrait suggests that she might be either Catherine Carter, who later married his brother Robert, or Catherine's sister Elizabeth.

68. Portrait of a Young Man
1853 Oil on canvas 24 x 20
(Private Collection)
Painted in Bethlem. So far the sitter has not been identified but a likely possibility is Dr. Charles Hood, whom it resembles and who at twenty-eight had just come to the hospital as Physician Superintendent. It is an extraordinarily compelling work, intense but completely tranquil in mood,

formal and yet relaxed, with an almost stylised simplicity which owes nothing to contemporary traditions of portraiture. The background is purely fantastic, the components probably taken from different sources including the sketchbook. The colouring is mainly green, blue green and brown, enlivened by the dashing scarlet fez lying on the seat, against which the black-suited figure takes on a dramatic stillness.

69. Family Portraits
1838 Watercolour 5 3/4 x 8
(From a Private Collection)
It has been not possible to identify all the figures, and at least one could not have been a member of Dadd's immediate family. Those who are certain are George William, age 16, top centre; Robert Dadd, age 49, top right; Robert jun., age 25, bottom left. The centre head seems to be a self portrait and the second from the right may be his second brother Stephen, age 22. The girl at the bottom is probably Mary Ann, age 24, and at the top, Sarah Rebecca, age 19. There are no other brothers to account for the man at the bottom right, unless this and not the other is Stephen.

70. Columbine
1854 Watercolour 14 1/4 x 9 7/8
(Private Collection)
Painted in Bethlem. The convolvulus with which the girl's head is wreathed is one of the most common plants to recur in Dadd's work, from the early fairy paintings onward; perhaps here he merely mistook its name. If so the theme of this charming picture rather falls apart; but since she is also wearing a lead-line (used for taking depth soundings), it might be safe to assume that some of his intention is now obscure. Her prototype in real life seems to have been the girl he had painted holding a rose in 1841.

71, 72. Boats: Two Pages from the Middle East Sketchbook
1842-43 Pencil 5 1/2 x 8 1/8
(Victoria and Albert Museum)
The fascination which shipping subjects held for Dadd was bred during his childhood in Chatham. It is no where so apparent as in the sketchbook which he brought back from the Middle East, many pages of which are completely filled with tiny boats, often only a half-inch high. Other pages have larger, more detailed studies, such as those shown here. More than twenty years later he was still drawing lovely little Eastern craft with their huge, butterfly sails, as for example in the two Egyptian 'fantasies'.

73. Reminiscence of the River Medway at Chatham
1857 Watercolour 7 x 10
(John Baskett Esq.)
Painted in Bethlem. According to Dadd's inscription this is a view from the Sun Quay at Chatham, and shows a *Yarmouth Bloater-Boat* departing. He added the quotation *'Juvat ire per undas'*. The scene is obviously, as described, a reminiscence, for it is not quite accurate enough to have been taken from one of his own sketches or any other direct source. But although the rise of the hill is a little too steep and the quayside buildings are slightly out of position, it shows Dadd's remarkable visual memory as well as his lasting

fascination with the Medway and its shipping. The church on the hillside has been altered in more recent years, but it is shown here very much as it looked when the Dadds lived in Chatham.

74. Reminiscence of Venice
1858 Watercolour $6\frac{7}{8}$ *x* $10\frac{1}{8}$
(Laing Art Gallery and Museum)
Painted in Bethlem. This is one of several watercolours to which Dadd has given the title of *Reminiscences*, but here he also notes that it is 'from a sketch made on the spot in 1842'. He was in Venice at the beginning of August that year, and the original drawing must have been in the sketchbook which he later had with him in Bethlem. The treatment of water as a regularly patterned surface is one aspect of the theme which fascinated him over many years, and here the luminous-edged ripples are comparable with the larger waves in *The Packet Delayed*. For Dadd, the essence of Venice clearly lay in her shipping rather than her architecture and the curving prow of the boat in the central foreground was cherished for use again in *Fantasie Egyptienne*.

75. Sailing Ships
1861 Oil on panel $7\frac{3}{4}$ *x* 21
(Mr. and Mrs. Paul Mellon, photograph courtesy of Thos. Agnew and Sons)
Painted in Bethlem. This painting is known only from a photograph. It is obviously a singular work with an air of mystery which would be impossible to define without seeing the original. It seems to be a companion picture to *The Diadonus*, to which its ghostly calm offers a complete contrast of mood.

76. Shipping in a Fresh Breeze
no date Watercolour $14\frac{1}{2}$ *x* 19
(Private Collection)
Probably painted in Bethlem. The treatment of the sea, similar to that in *Jesus Christ Walking on the Sea,* would suggest a date in the early 1850s. The colour here is very much stronger, an overall greenish blue, which might give some indication of the original colouring of the other work. The central ship has the name 'Industry Portsmouth' on the stern. The smaller one to the right, with the name 'Fanny' on the sail, is reminiscent of *The Pilot Boat* in the way it cuts through the waves stern down, though here there is a great deal more movement of both sea and ships.

77. The Pilot Boat
1858-9 Watercolour $11\frac{1}{8}$ *x* $17\frac{3}{4}$
(The Tate Gallery)
Painted in Bethlem. With characteristic precision Dadd dated this watercolour 'April 1859. Incepit 1858', and it is no surprise that it should have taken many months to complete. His creation of the sea, here and in a few other works such as *A Fishing Fleet in a Storm,* is a uniquely personal form of expression and the concentration with which its texture is built up from speck upon speck of colour, is a token of his untiring delight in ships and the sea. The scene has something of the static frieze-like quality of many of his works, giving it an added intensity like an image frozen in a dream and enhanced by the monochrome misty blue colour.

78. Sketch for Poverty
1853 Watercolour $13\frac{3}{4}$ *x* 10
(Private Collection)
Painted in Bethlem. There is no certainty that this sketch belongs in the *Passions* series, but it was placed among them at the sale of Sir Charles Hood's pictures in 1870, and seems to fit the pattern, at least as an early prototype. Musical instruments feature in a number of Dadd's works, but this is possibly the only one in which a violin is shown although he played the instrument himself. There is some resemblance to his father, though older than Dadd would have remembered him, in the face of the blind fiddler.

79. Sketch to Illustrate Splendour and Wealth
1853 Watercolour 14 *x* 10
(Newport Museum and Art Gallery)
Painted in Bethlem. Like *Poverty* this drawing was treated as one of the 'Passions' by its first owner Sir Charles Hood, though it cannot be placed with certainty among them. It is subtitled 'subject Cleopatra dissolving a pearl - a seed', and illustrates the legend in which, Cleopatra at a banquet given for Mark Anthony in Alexandria, dissolves one of her pearl ear-drops in a cup of wine and drinks it in order to impress him still further with her riches. It is not known from which source Dadd took the story—although not in Shakespeare, the story was well-known as was Reynolds's portrait of Kitty Fisher as *Cleopatra dissolving the pearl*. This is the richest in colouring of all the Passions' and related watercolours, though still far from gaudy; the strong yellow of the legs of the couch and elsewhere and the coral pink of one of Cleopatra's robes are the most striking colours, with shades of blue and purple in the rest of the fabrics and echoed in the background.

80. Sketch to Illustrate Jealousy
1853 Watercolour $13\frac{3}{4}$ *x* $9\frac{1}{2}$
(American Shakespeare Theatre, Stratford, Connecticut)
Painted in Bethlem. This drawing bridges the gap between the *Passions* series proper and the two earlier works, since it is not given the full title of 'Sketch to Illustrate the Passions' but it very obviously does so. Like *Hatred* a quotation identifies the scene: 'Othello. Shakespeare's Play - Iago. Sweet Desdemona Oh! cruel/Fate that gave thee to the Moor'. The background obviously makes use of material from the sketchbook. The drawing is known only from a photograph.

81. Sketch for the Passions. Love
1853 Watercolour 14 *x* 10
(American Shakespeare Theatre, Stratford, Connecticut)
Painted in Bethlem. This is known only from a photograph, but the drawing seems to resemble Maclise's style more closely than most of the series. There are many Dadd hallmarks in the picture; the glimpse of landscape in the background, in particular, looks forward to the much later *Wandering Musicians* while the clump of poplars can be found in the nearly contemporary *Portrait of a Young Man.*

82. Sketch of the Passions. Hatred
1853 Watercolour $12\frac{1}{4}$ *x* $10\frac{1}{8}$
(The Bethlem Royal Hospital, photograph courtesy of The

Painted in Bethlem. The scene is the murder of Henry VI by Richard, Duke of Gloucester: 'See how my sword weeps the poor King's death./Vide Shakespeare's Play.' This more appropriately might have been used to illustrate *Murder* and the figure of the Duke obviously resembles his namesake in more than the mere coincidence of their names. The choice of a theatrical subject cannot disguise Dadd's personal involvement in this reconstruction of his own act of killing— it is truly a frightening picture made even more so by the use of spine-chilling shades of purplish blue as the dominant colour. One of the most disturbing features is the presence of some of his most beautifully controlled drawing and modulations of colour, giving extra emphasis to the deliberate ferocity with which it is charged.

83. Sketch to Illustrate the Passions. Treachery
1853 Watercolour 14 x 9 $\frac{3}{4}$
(Mr. and Mrs. Paul Mellon)

Painted in Bethlem. This is not Dadd's only work to feature the Chinese, but usually they are well concealed. In *The Flight out of Egypt,* a figure who is almost certainly Chinese lurks behind the Negro and in *The Fairy Feller's Master-Stroke,* the tiny elf peering through the grass at the back (directly below the bugler) is identified by Dadd in his poem as 'a small member of the Chinese Small Foot Societee'. Perhaps the cheerfully treacherous characters seen here, about whose activities it would be useless to speculate, are members of the same society, though it is not apparent whether Chinese treachery was really one of Dadd's obsessions or just an *ad hoc* joke. There is an appropriately yellow tinge to the colouring, which is more than usually ploychromatic in the pattern on the main figure's robes.

84. Sketch to Illustrate the Passions. Gaming
1853 Watercolour 14 $\frac{3}{8}$ x 10
(The Ashmolean Museum)

Painted in Bethlem. By comparison with the rest of the series the colouring here is rather harsh, but the handling of it and the drawing are fine. There may have been Dutch paintings of card players at the back of his mind, but the conspiratorial figure in the top right corner is pure Dadd.

85. Sketch to Illustrate the Passions. Brutality
1854 Watercolour 14 $\frac{1}{4}$ x 10
(The Bethlem Royal Hospital)

Painted in Bethlem. The setting here may be a fisherman's cottage such as Dadd would have remembered from his childhood at Chatham. This is a good example of his ability to delight by the sheer beauty of his drawing and colour, even where the subject is an unappealing one. It is painted on brown paper, like many of the *Passions* works, in mainly subdued tones of blue, grey and pinkish brown. The group standing in the doorway and picked out by the sunlight outside is one of the best of the subsidiary vignettes which are sometimes found in these figure compositions, and is capable of standing alone beside the main group.

86. Sketch to Illustrate the Passions. Ambition
1854 Watercolour 14 $\frac{1}{2}$ x 10 $\frac{1}{4}$

Painted in Bethlem. The subject, reinforced by the sub-title 'Vaulting Ambition mocking the meat it feeds on', seems to have had personal significance for Dadd,though what it was is not known. There is possibly a suggestion of family portraiture in the main figures, while the Mediterranean background may have no relevance outside its picturesque value. On the evidence of the writing, the sum in the top left-hand corner could have been written by Dadd himself, though it is difficult to imagine him scribbling on his own drawings.

87. Sketch to Illustrate the Passions. Agony - Raving Madness
1854 Watercolour 14 x 9 $\frac{7}{8}$
(The Bethlem Royal Hospital)

Painted in Bethlem. There may be something of Caius Gabriel Cibber's statue of *Raving Madness* which stood in the entrance hall to Bethlem Hospital in Dadd's portrayal of the same subject; certainly there is nothing of the Bethlem he knew in the physical conditions chosen for the setting. This is a conventional, almost literary, concept of the chained lunatic lying on straw which rightly belongs at least half a century earlier. But the image is only a vehicle for something far more personal, explicit in the first title 'Agony', which Dadd has to tell the world about madness. This is no objective view, Dadd's madman is not, as Cibber's, straining against the fetters which have been placed on him by his fellow men, but struggling impotently to free himself from the inner torments of his own mind. It is one of his most moving works.

89. Sketch to Illustrate the Passions. Avarice
1854 Watercolour 14 $\frac{1}{2}$ x 10 $\frac{1}{4}$
(Whereabouts unknown, photograph courtesy of Thos. Agnew and Sons)

Painted in Bethlem. This drawing is known only from a photograph. A number of the accessories appear elsewhere; the plumed helmet is found in at least three other pictures (not reproduced), while the sword features in many works, often with little more justification than Dadd's own obsession with it.

89. Sketch to Illustrate the Passions. Melancholy
1854 Watercolour 14 $\frac{3}{8}$ x 10
(From a Private Collection)

Painted in Bethlem. This is one of the gentlest of the 'Passions' drawings and an interesting example of Dadd's use of a single dominant figure, in a vertical format, to create an atmosphere of total peace and calm. Instead of the hard conflicting diagonals and rigid verticals with which he generally expresses tension and strife, we see the figure draped in a relaxed curve around the rock face, melting into the perimeter of the circle against which he rests. The angle of the staff emphasizes rather than opposes the soft lines, and reinforces the languid gesture of the right arm. Melancholy light browns and blue grey sustain the atmosphere, the pilgrim's golden brown robe, harmonizes in mood, but singles him out as the dominant presence.

90. Sketch to Illustrate the Passions. Idleness
1853 Watercolour 14⅜ x 10⅛
(Victoria and Albert Museum)
Painted in Bethlem. The tonality is similar to that of
Brutality with a few touches of bright red in the contents
of the old woman's basket. The basket with its trinket
boxes and pieces of patchwork is vividly remembered, and
this applies to the whole scene. Although one of the most
artificially and cleverly designed groups it is also one of the
most naturalistic in appearance, and it is hard to realise
that these figures could not have been painted out-of-doors
in the sunlight of an open street. It looks as though models
have been used before, and the hideous old woman could be
the same person as the man apparently sleeping in *The Child's
Problem.*

**91. Sketch to Illustrate the Passions. Insignificance or Self
Contempt**
1854 Watercolour 14 x 9⅞
(The Bethlem Royal Hospital)
Painted in Bethlem. The figure is a portrait of J. M. W.
Turner, as Dadd must have remembered him from his days
at the Academy Schools. On the face of it this seems to be a
rather light-hearted caricature, even though the significance
of all the details is not apparent - is this humble being
intended to be Mr. Crayon, the drawing master himself, or is
he the single gentleman seeking furnished apartments? And
Why Turner at all? But leaving these puzzles aside, it is
difficult to reconcile the simple pleasantry of the drawing
with the impassioned outburst of the subtitle, where even
Dadd's normally meticulous script turns into a rushing
longhand: 'Insignificance or Self Contempt - Mortification -
Disgusted with the world - he sinks into himself and In-
significance.' The drawing is on brown paper.

92. Sketch to Illustrate the Passions. Self-conceit or Vanity
1854 Watercolour 14 x 9¾
(The Bethlem Royal Hospital)
Painted in Bethlem. Dadd usually gives a reference for his
Shakespearean illustrations, and although this would seem at
first to be from Shakespeare it does not fit any identifiable
scene, though it may have been inspired by ideas of Malvolio.
The drawing is on brown paper, but the normally subdued
tones are here enlivened by touches of scarlet and bright
blue in the costume and an almost luminous green in the
peacock feather.

93. Sketch to Illustrate the Passions, Deceit or Duplicity
1854 Watercolour 14⅜ x 10¼
(The Bethlem Royal Hospital)
Painted, in Bethlem. There seems to be a personal statement
in this drawing, though it is hardly surprising that coming
from Dadd it is not a very plain one. The hideous old hag
deceives the world with the mask of a fair young girl - or
does the innocent girl reveal beneath her mask that she is
already corrupt? The serpent with a head remarkably like
that of Dadd's father perpetually tempts and deceives the
untarnished Eve - except for the possibility that she is
tempting him. Anyway they, or we, are all being taken in by
the ultimate deceiver, death, whose skull lies ready at hand
for deceiver and deceived alike. The curious chair and

unresolved architecture do little to explain the ambiguities.
The colouring is basically of a greenish yellow, with touches
of blue and coral.

94. Sketch to Illustrate the Passions. Murder
1854 Watercolour 14¼ x 10¼
*(The Bethlem Royal Hospital, photograph courtesy of The
Paul Mellon Centre)*
Painted in Bethlem. If there was one subject which Dadd
could have depicted firsthand it was murder, and already
he had drawn several scenes of violence that came very near
to his own experience. But when illustrating the act of
murder itself he chose to use the archetypal theme of Cain
and Abel, just as when illustrating madness he chose a setting
far removed from the one closest to him. This simple and
literal illustrations of the story is a fine, free composition,
looser in texture than any of the other watercolours and
light in tone.

95. Sketch to Illustrate the Passions. Grief or Sorrow
1854 Watercolour 14 x 10
*(The Bethlem Royal Hospital, photograph courtesy of The
Paul Mellon Centre)*
Painted in Bethlem. This is very rare among Dadd's figure
compositions in that it takes a purely symbolic approach to
the subject. The others, particularly those of the *Passions*
series, are almost literally 'sketches' in the theatrical sense,
small scenes illustrating the theme in concrete terms. Here
the feeling of emotional intensity is created almost entirely
through atmosphere, in the sad grey monochrome and the
spectral trees, and in the diagonal upsurging movement,
explicit in the foreground trees and latent in the garments of
the seated figure, which seems to carry her grief upwards on a
wave of desolation.

96. Sketch to Illustrate the Passions. The Recklessness
1855 Watercolour 14 x 10
*(The British Museum, photograph courtesy of The Paul
Mellon Centre)*
Painted in Bethlem. The lightness of the subject is marked
by a tonality much lighter than that of the other *Passions,*
with a near monochrome pale beige in the rocks and distant
scenery, bathed in bright sunlight, with a predominance
of grey and yellow in the costumes. Dadd has used some
elements from the earlier sketch *Idleness* here, notably the
pose of the man on the right which is identical with the
boy's, but in reverse. The castle on a high rock, which
appears in so many works, is prominant here.

**97. Sketch to Illustrate the Passions. Suspense or Expect-
ation**
1855 Watercolour 14½ x 10¼
(E. Holland-Martin Esq.)
Painted in Bethlem. Like *The Packet Delayed* and other
pictures of children, Dadd here paints recollections of his
own past with total veracity but without any sense of
nostalgia, vividly recapturing the spirit which belongs
uniquely to the preoccupations of childhood. The changed
perception of childhood which comes with increasing
distance from it was, to some extent, impossible for Dadd
by his isolation in a place where he could never see children.

In his uncluttered memory they continued to be represented by his former self and his companions, which is probably one reason why his view of them remained completely unsentimental. The setting is obviously a familiar one from his days in Chatham, and a part of the town can be seen climbing the hill at the back. Dadd's obsession with clothing his children in ruffs, as in *Juvenile Members of the Yacht Club* and *The Child's Problem,* is again seen here.

98. Sketch to Illustrate the Passions. Want the Malingerer
1856 Watercolour $14\frac{3}{16}$ x $10\frac{3}{16}$
(Victoria and Albert Museum)
Painted in Bethlem. To judge by the surviving work Dadd had finished his main output on the *Passions* sketches by 1855, and this, like the other isolated later drawings, has a character all its own. The personal involvement in scenes of high dramatic tension is gone, and here he looks with unaccustomed compassion on the plight of other sufferers. This is reinforced by the lettering on the paper held by the man: 'GOOD CHRISTIANS [illegible] . . . ON TO A PORO FORLORN OUTCAST'. The delicate colours, green blues and pale mushroom, are as cool as the charity denied to the poor wanderers, and in the distance is a glimpse of the much loved scene from which Dadd himself is now an outcast, the river Medway at Chatham. The old woman crumpled against the steps belongs to the same family as the woman with a basket in *Idleness* but here she is viewed with pity instead of aversion.

99. Sketch to Illustrate the Passions. Patriotism
1857 Pen and ink and Watercolour $14\frac{3}{16}$ x $10\frac{3}{16}$
(Victoria and Albert Museum)
Painted in Bethlem. This extraordinary drawing shows that despite his mental disorder Dadd retained full control of his intellectual powers. The work is full of inventive ideas, word play and punning, and if the humour seems a little immature, this can probably be accounted for by changes in taste. The idea is based on the seige operations at Chatham performed by the town's garrison, a high point in the local calendar for which maps of the fortifications and plans of campaign were published in advance. Dadd must have studied many of these maps and plans and draws on his memory of them here. Many of the names which he has invented; 'Biggenuph Island', 'Nowbegin Mansion', 'General Popgun's Camp', 'Fort Sosorri', are at the rather juvenile level of popular games of the period, but a number seem to have some personal significance. Of these, a few refer to his present condition, the most obvious being the 'Lunatic Asylum called Lostwithal', and such places as the 'Gate of Slavish Hope', 'The Devil's Fortress' and the 'Bay of Victimsall'. Others must have some actual or imagined autobiographical implication, and places like 'Headland called Rival's Taunt', 'Pool called The Spendthrift Brother', and 'Drudge's Sneer Rivulet' are hardly likely to have featured on the average Victorian drawing-room board game. The long text on the left-hand side is a description of the engagements which were fought during the campaign, again influenced by accounts of the Chatham manoeuvres. In parts it is quite funny, in others undistinguished though mildly amusing, in places even bawdy; but as an example of sustained invention it shows little sign of wandering

except toward the end. Here there are hints of a recognizable pattern of thought disturbance in which apparently exalted ideas turn out, on examination, to be inconsequential. Dadd certainly stops well this side of incoherence, but in reading some passages it is not hard to believe the descriptions of his 'rambling' talk: 'The circumjacent country relates to the mysteries of life, but it is imperfect of course and has the same basis as all other mysteries worth noting, viz. broken hearts, bruised spirits, and the art of victimisation in those matters . . .' Another interesting feature is the frequent incursion of the Devil into the story along with the theme of 'victimisation', giving a rough idea of what Dadd's conversation must have been like; long stretches of perfect lucidity and intelligence, suddenly breaking off in favour of some irrelevant preoccupation which could not be kept out any longer and becoming apparently irrational in consequence. The drawing itself is clever and inventive in Dadd's best style, and the little 'Scale for abolishing the difficulties of proportion' in the top right-hand corner should not be missed.

100. Folly, Joy, Grief: Panels from the Stage at Broadmoor
1874 Oil on hessian 14 x $36\frac{1}{4}$
(Broadmoor Hospital)
Painted in Broadmoor. These are three of the six panels which Dadd painted for the front of the stage in the men's recreation hall at Broadmoor, and the others represented *Avarice, Love* and *Hatred.* They may have been inspired, at several removes, by Pompeian wall friezes depicting cupids playing, particularly those which show them holding masks in front of their faces. Nothing else has survived from the stage, scenery and decorations which Dadd provided for this room, except a sketch for the drop-curtain. The colouring is stronger than in much of his late work, but still tends towards blues and browns.

101-105. Housekeeper, Scribe, Female Head, Male Head, Jester
After 1864 Glass panels 25 x $14\frac{1}{2}$
(Broadmoor Hospital)
Painted in Broadmoor. These are five of the eleven glass panels decorated in a style intended to imitate etching. All but the two heads shown here are full-length figures, the others being a *Cook, Priest, Troubadour, Turnkey, Water* or *Wine Carrier,* and a *Girl with a Lily.* There is no record of the panels' original function, but the support seems to have been ordinary window glass. Although records indicate that Dadd worked in many unaccustomed media while at Broadmoor, making slides and diagrams for lectures among other things, these panels are the only surviving examples and show his usual complete confidence in everything he undertook.

SELECT BIBLIOGRAPHY

Allderidge, Patricia *The Late Richard Dadd,* catalogue of the Tate Gallery Exhibition, 1974
Greysmith, David *Richard Dadd,* 1973
Maas, Jeremy *Victorian Painters,* 1969
Ormond, Richard *Daniel Maclise,* Arts Council of Great Britain Exhibition, 1972
Reynolds, Graham *Victorian Painting,* 1966

Early Life and Work
Annual Reports Chatham and Rochester Philosophical and Literary Institution, 1828
The Art Union October 1843; 1844, 1845, 1848
Frith, W.P. *My Autobiography and Reminiscences* Vol. III, 1888
Graves, Algernon *The British Institution . . . a complete dictionary of contributors,* 1908
 The Royal Academy of Arts, A Complete dictionary of contributors
 Vol. II, 1905
A Handbook to the Gallery of British Painting in the [Manchester] *Art Treasures Exhibition,* 1857
Imray, John 'A Reminiscence of Sixty Years Ago,' *Art Journal,* 1899, p 202
London Post Office directories and poll books
Robson's *London directory*
Scott, William Bell *Autobiographical Notes* ed. E. Minto, 1892, pp 110-111, 172

Murder, Inquest and Court Proceedings
Wood, William *Remarks on the Plea of Insanity,* 1851, pp 41-42 (contains Dadd's own account of his delusions)
Dover Chronicle, August 17, 1844
Kentish Independent, September 2, 1843, August 3, 1844
Kent Herald, September 14, 1843
Maidstone Gazette and Kentish Courier, September 5, 1843
Rochester Chatham and Strood Gazette, August 6, 1844

Life in Bethlem and Broadmoor
General Reports of the Royal Hospitals of Bridewell and Bethlem, 1845, etc.
'The Charity Commissioners Report' 32nd Report part VI, Bridewell and Bethlem, 1840
The Quarterly Review vol. 101, 1857, pp 361-2 (Bethlem)
The World, December 26, 1877, pp 13-14 (Broadmoor)

Manuscripts and Other Sources
Archives of the Bethlem Royal Hospital and the Maudsley Hospital
Dadd family papers (private collection)
Letters of Sir Thomas Phillips (private collection)
Public Record Office, Home Office papers
Record Office and Local History Department, Liverpool City Libraries, Mayer papers Acc. 2528; letters of William Clements
Registers of St. Mary's Church, Chatham, and St. Mary's Church, Gillingham.